JUST ONE FLASH

A PRACTICAL APPROACH TO LIGHTING FOR DIGITAL PHOTOGRAPHY

ROD AND ROBIN DEUTSCHMANN

AMHERST MEDIA, INC. ■ BUFFALO, NY

Acknowledgments

There is nothing more satisfying than having the opportunity to share your passion with those you love. With this in mind, we extend our deepest gratitude to both Holly Kidd and Alexis Deutschmann for their willingness to put on a smile under any condition. Their participation in the making of this book was invaluable.

We also thank Jacob, Ryan, Tara, and Jay for their support—as well as the many In Focus Learning Center (IFLC) students whose quest for the truth has pushed us along the path to perfecting our own skills and techniques. This experience has enriched our lives immensely. Thank you for sharing it with us.

Published by:
Amherst Media, Inc.
P.O. Box 586
Buffalo, N.Y. 14226
Fax: 716-874-4508
www.AmherstMedia.com

Publisher: Craig Alesse
Senior Editor/Production Manager: Michelle Perkins
Assistant Editor: Barbara A. Lynch-Johnt
Editorial Assistance from: Chris Gallant, Sally Jarzab, John S. Loder

ISBN-13: 978-1-60895-250-2
Library of Congress Control Number: 2010904496
Printed in Korea.
10 9 8 7 6 5 4 3 2 1

Check out Amherst Media's blogs at: http://portrait-photographer.blogspot.com/
http://weddingphotographer-amherstmedia.blogspot.com/

Table of Contents

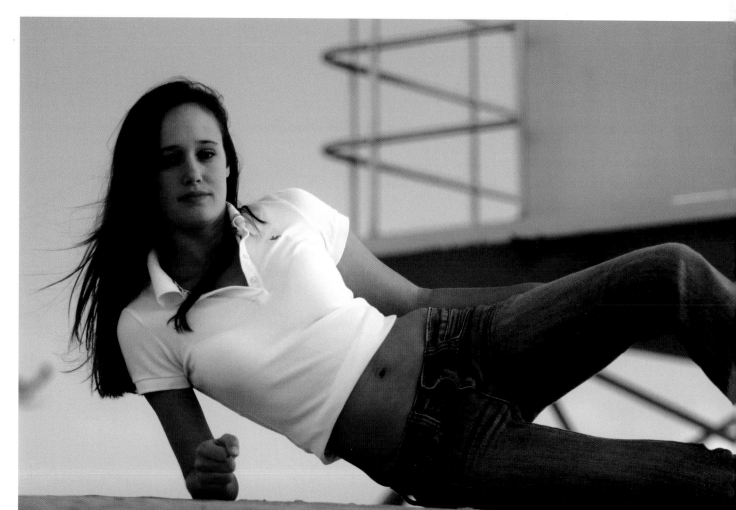

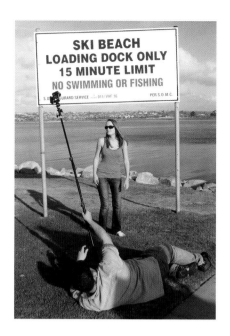

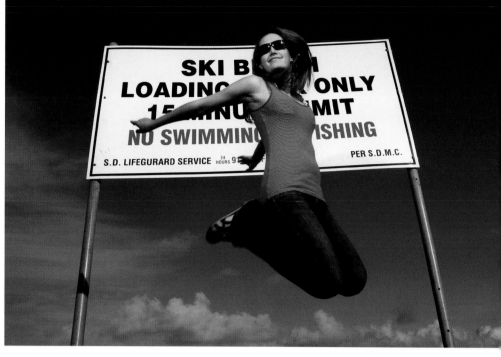

About the Authors

Rod and Robin Deutschmann have been teaching people to be artists with their cameras for years. Taking a practical approach to modern photography, the duo strips the nonsense from the facts and the hype from the truth. They believe that creativity lies in the artist's soul and not his camera bag. Touting the advantages of manual control, they offer a fresh view of photography that rebels against the norm. Their innovative approach and down-to-earth style have garnered them a loyal following of Southern California photographers. In books like *Off-Camera Flash Photography* and *Multiple Flash Photography* (both from Amherst Media), they are now bringing their unique vision and perspective to everyone. Rod and Robin are award-winning, fine-art photographers and individual recipients of a 2007 Thomas Jefferson Award. Visit them at www.facebook.com/IFLCSanDiego.

Robin Deutschmann.

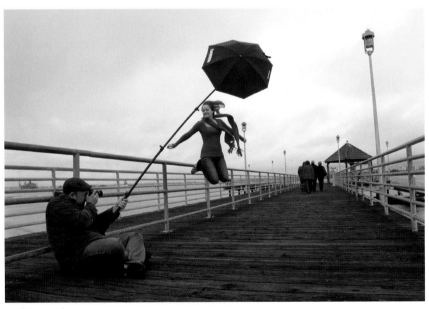

Rod Deutschmann.

1. A Unique Vision

Creating art with a flash has little to do with the flash itself. It's more about the artist and his determination to bring a unique vision to life.

Photography is not about capturing how something looks, it's about sharing with others how that "something" makes you feel. It's about expressing an emotion and creating a feeling. The flash is simply one tool (of many) that allows it to happen.

Epiphany

There are certain instances in every photographer's life that prove more important than others—things we remember as turning points in our careers. These usually have nothing to do with any photos we've taken. Rather, they revolve around a specific moment in time when our vision as an artist expanded.

Usually, our first epiphany comes when we take full manual control of our camera and realize that "auto-anything" can't get us the image we envision. The second comes the first time we add light with a flash. This enlightening moment shines as a beacon to our creative soul, lighting the way to true artistic freedom. Adding flash gives you choices. If something is dark, you can change it. If something is moving fast, you can freeze it. If your message—the real reason for raising your camera in the first place—is hidden in shadow, you can illuminate it.

This is powerful stuff that will change your photography forever. You can now go into any situation with confidence and direction, no longer having to hunt for the best lighting. If it's not there, you can just make it yourself. No longer will you have to run from the shadows or settle for second best. With flash, you are in charge of the way the world is lit. If you don't like it, you can fix it.

Usually, our first epiphany comes when we take full manual control of our camera.

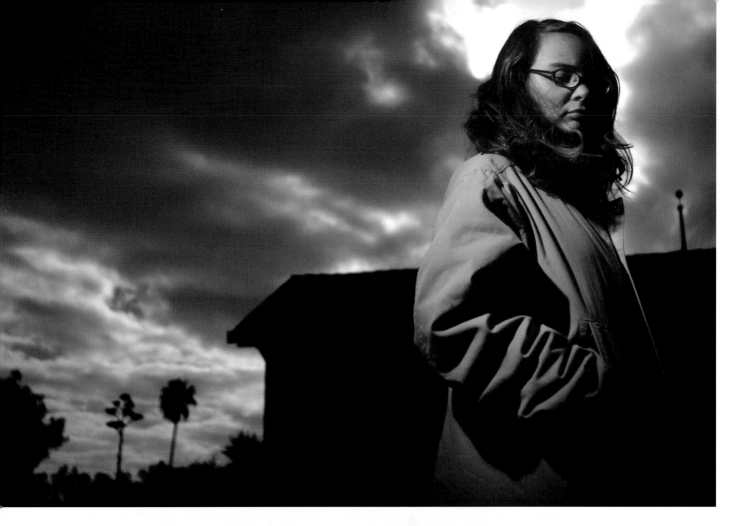

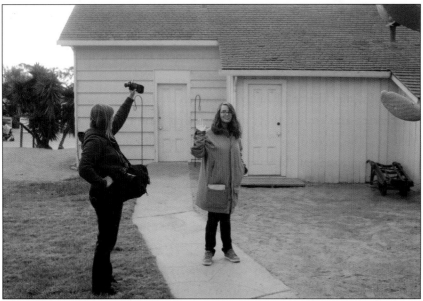

Too many people believe a flash is used simply to eliminate shadows. If that was the case, then the image at the top of this page would not exist. As shown in this image, shot on auto, the natural lighting was quite flat. This is where the vision of an artist comes into play. The photographer envisioned something different than what was in front of him; he then simply needed a tool to make it happen.

ABOVE—A single off-camera flash was called into play, its use dictated by necessity. The day was cold and slightly overcast. The photographer, wanting to create a dramatic representation of what was before him, began by dialing in the aperture, shutter speed, contrast, and white-balance settings that best illustrated his vision. He started with his background, taking light away to bring out the mood. This had the consequence of sending his model into darkness as well. The flash was then called upon to fix the problem. Its power, angle of view, and direction were also manually adjusted. Keep in mind that the creation of photographic art *cannot* be done with an automated approach. The image looks nothing like how the scene appeared. That "normal" view is all the automatic settings (as illustrated in the image to the left) could have delivered.

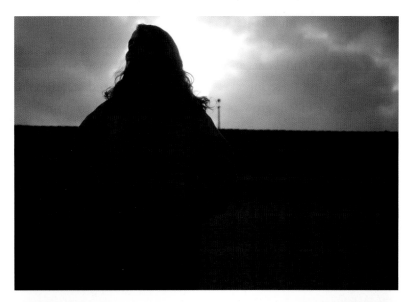

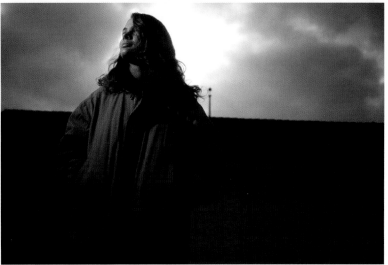

Tenacity and courage can only take you so far. If you can't visualize how something *could* look, you won't have anything to shoot for. The best advice we can give to new and eager flash students is to simply think outside of the world where they live. Imagine something different and try to make it happen. These images illustrate not only the power the flash has on lighting a subject, but also its ability to illuminate an idea.

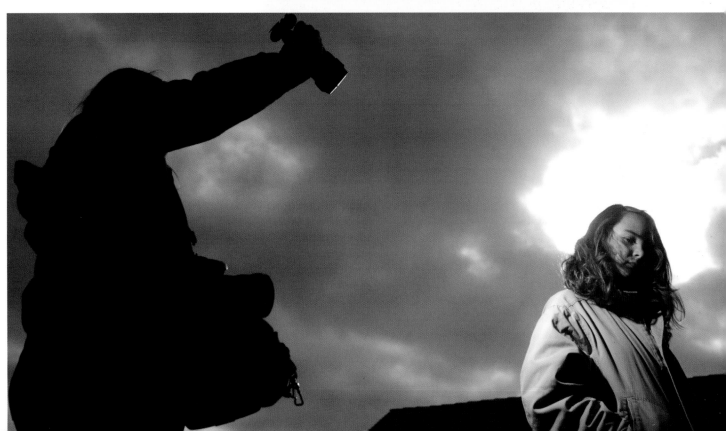

Adding light with a flash is a pretty bold move; adding illumination will most certainly change the way the world appears. And don't be discouraged if you initially find yourself with horribly overexposed and unfocused pictures. Making these mistakes—bright, colorful, and staring you in the face—is how you will grow as an artist. All you need to do is learn from them.

Adding light will also alter your perception of reality; you'll see extremes that others can't. You'll look at the background as a source of inspiration, not just a distraction, knowing that you can light it any way you want. You can make the background appear darker than normal—and with that decision made, add light to the foreground, giving your message an unbelievable sense of power and authority.

In short, becoming comfortable with using a flash will quickly take you beyond creating "average" photos; it will free you to see what's *really* possible. And your creativity won't be the only thing that is freed; unlike those with bags full of gear, you'll also be free to travel light—unencumbered and ready to respond or create at a moment's notice. There is no lengthy setup time when using just one flash. You won't require special supports, bags, or huge modification tools—it's just you, your camera, and your flash. Sound like fun?

Adding light will also alter your perception of reality; you'll see extremes that others can't.

The Challenges

Flash photography can be a complicated process; for new photographers, it is often tricky and unforgiving at best. When faced with the apparent complexity of the issue, many shy away; they decide to abandon their original vision and simply deal with the situation the best they can. They may raise their ISO, roll the dice and shoot with a slower shutter speed, or simply take a dark photo and then try to "fix" it later in their computer.

A positive attitude is the most important ingredient when learning to be a creative flash photographer—that, and a bunch of extra batteries, of course.

You'll be gaining experience, your

vision will grow, and your photos

will shine because of it.

There is no shortcut to artistic expression and creative control. Picking a shooting mode or adding a filtered effect later in Adobe Photoshop is not artistic expression. If anything, it stifles your ability to visualize and makes you dependent on others—when all you really want is to express yourself. If you're serious about wanting to be an artist with your camera and flash, then learn to shoot manually. Creativity is not a camera "mode," and you can't use a computer to fix your poor judgement.

If you never push yourself—if you never accept a challenge—you'll never discover anything new. Learning to use a flash well takes time, patience, and determination. Yes, it can take a while to master. Yes, you'll be shooting a lot of really bad photos before the good ones start flowing. But through it all, you'll be gaining experience, your vision will grow, and your photos will shine because of it. Flash photography is not hard; it's just an option—an option that every serious photographer should master.

The Three Secrets to Unlocking Your True Potential as a Creative Flash Photographer

1. **Be in full manual control of your camera and flash.**

 Next to your imagination and experience, your tools are pretty important when creating a graphic message. It's best to know them inside and out; when problems arise—and they will—you have to understand all of your options, including those that have nothing to do with the flash unit itself. If you haven't learned to go manual, do it. Without the basics firmly understood, you will fall short of your goals.

2. **Know why you are adding light in the first place.**

 Every photographer needs a goal, a reason to add light in the first place. Visualize the end result, then keep working until you have it. Then, and only then, explore other possibilities.

3. **Be willing to learn from your mistakes.**

 Don't give up when things get hard. The experience that your bad images offers helps you to grow as an artist. Revel in your mistakes as much as you do your successes. Use your LCD monitor as a guide, then make whatever adjustments are needed to produce the results you desire.

Start with the Basics

To add light creatively, you simply need a reason to do it, a tool that allows it to happen, and the wherewithal to make it work. If you are prepared to take responsibility for your images, this is not a complicated process. You simply recognize when natural light options fail and employ a flash to even the odds.

To do this well, to be really creative with a flash, you need to be in full manual control of your equipment. This is a hard nut to crack, but it's a necessity for the artist in search of meaning. Nothing creative in photography has ever been accomplished in an automatic setting. A machine can't think, a lens can't compose, and a sensor—no matter how much money you might have spent on it—can't possibly pick the best light for your message. (*Note:* Believe it or not every bad photograph you've ever taken really *was* your fault; the machine was simply doing what you told it to do. Even when shooting in the pure automatic mode, the camera is simply following a set of predetermined options that were chosen by you when you picked the mode to shoot in.)

If you haven't mastered the basics of photography yet, now would be the time. There is no use in trying to add light if you can't control what's in front of you first. You don't want to be worried about basic mechanical issues when confronted with the complex scenarios that require a flash. You have to be able to move quickly, making decisions, weighing options, and visualizing an end result. You can't be bogged down by the basics. You need to be confident in your own abilities before you can start being creative with a flash.

Practice, Practice, Practice— With Whatever You Own

Even if you haven't bought a flash yet, there's no excuse not to practice. Most photographers already have a flash with which they can practice—a flash that is built right into the camera. The pop-up flash, while denounced by most professional photographers, is actually quite a valuable tool. When controlled well, it can produce some very nice images. Sure, it has its limitations, but it's still a light source and can illuminate your ideas wonderfully. It can also be used as a training device to prepare you for your first external flash unit. In the next chapter, we'll be diving deep into the pop-up flash and what it offers. We'll explore how to adjust its physical and apparent power output and how to modify it.

To add light creatively, you simply need a reason to do it, a tool that allows it to happen, and the wherewithal to make it work.

What to Buy First

Once you've mastered the pop-up, obviously you'll want an external flash. If you don't already have one, let your budget be your guide. As we tell our students, the best flash is the one with the freshest batteries.

Other than a flash, there isn't a whole lot to buy. Sure, there are some important options and really fun toys to play with (light stands, communication devices, modification tools)—but the basic gear involves you, your camera and your flash. When you're ready to move on to accessories, you'll know it.

The key to success (and keeping your sanity) is to not buy everything all at once. Take this journey in steps and buy only what you need, when you need it. Each tool you purchase will have a specific purpose. If you don't know what that is, don't buy the tool. There is a good chance you may never need it and there is nothing worse than camera gear that doesn't get used.

You will be faced with a plethora of options when you first buy a flash, including modification devices (such as the softbox pictured here), support options, and communication tools. It's best to avoid buying *anything* until you know exactly why you need it.

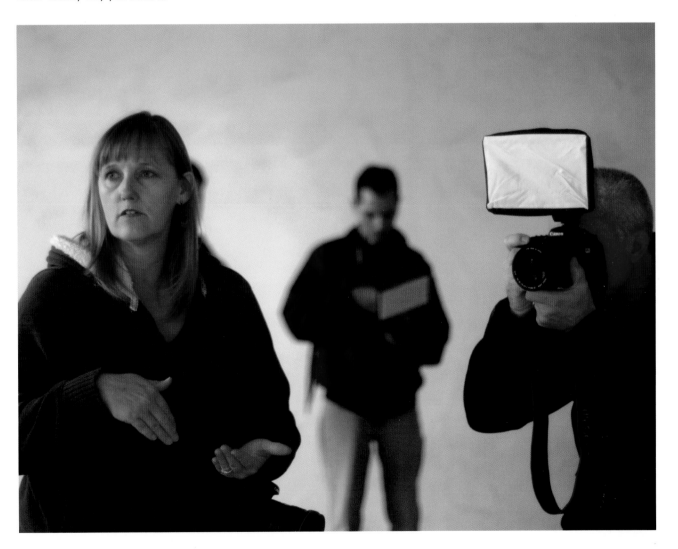

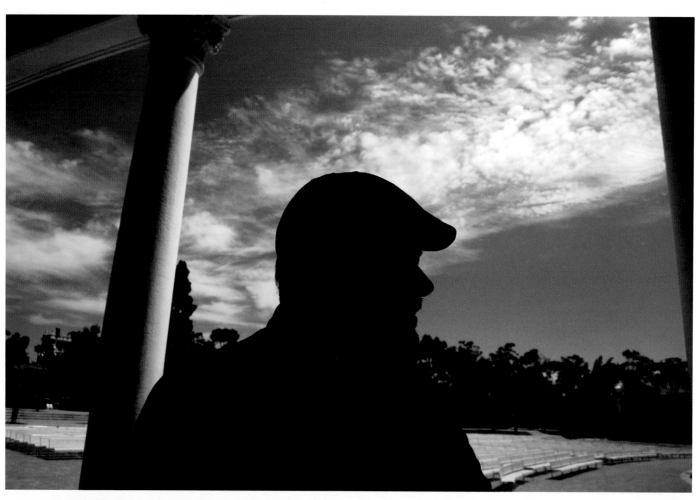
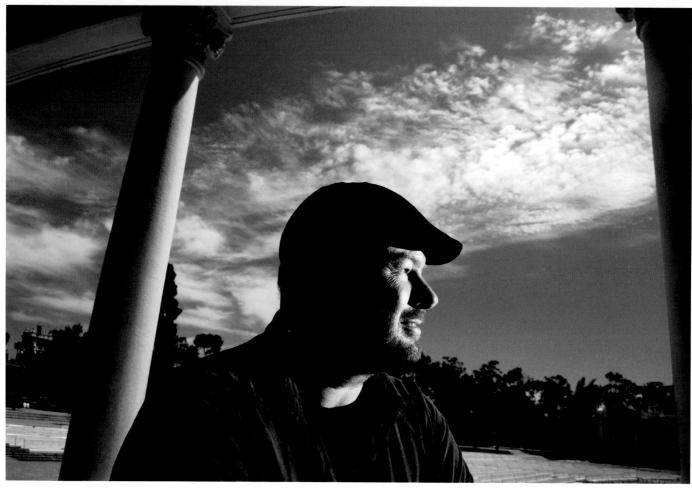

The Useless Pursuit of the "Best" Gear

Museums and galleries are full of images that were not shot with the "best" lens, flash, camera, or electronic sensor. Those images are great not because of what they were shot with but because of what they contain—heart, vision, and a story. These images reflect the artist's passion and strength. They highlight his courage to push beyond the "expected" image and offer something different.

An artist doesn't just take pictures of things, he creates a message—and the tools he uses to get that message across (believe it or not) don't matter. Whatever works, works. If someone tells you something different, they are probably trying to sell you something. Spending your life in the useless pursuit of the world's "best" gear is a fool's errand; there will always be a better machine around the corner. Besides, all of that time spent worrying could be spent learning. So stop examining and start experimenting. Get outside and shoot.

Taking Responsibility

New photographers usually point their camera at a subject and shoot, hoping that their gear is good enough to take a pretty picture. When their images lack power or punch, they simply buy a different camera. They believe the hype—they go for more megapixels, expensive lenses, and faster processors. They look for the best sensor and "cleanest" lens. They even believe that a computer program can clean up their mess and transform a broken image into something wonderful. They will buy whatever they can to avoid failure.

When a seasoned photographer makes a mistake, however, he doesn't blame his equipment. He can admit to some of the fault for the error. He simply looks at his monitor and sees what's wrong. If his depth of field is lacking, he adjusts his aperture. If his perspective is off, he moves forward or back. If his composition is weak, he looks closer at the graphic elements in front of him and makes some real decisions as to their placement. If his lighting is off, he fixes it. He knows that he can correct most problems with the addition of light. So he employs a flash and starts pumping light into his messages. Not only do his images improve but his focus on artistic expression begins to shine. He's no longer simply taking pictures, he's creating art.

FACING PAGE—The addition of light is not a hard thing; recognize what needs light and add it. How much light to add, what angle it should come from, how the flash should be triggered, and what it will sit upon are tougher questions—and they need to be answered. In the top photo, no flash was used. In the bottom photo, a simple off-camera flash was pointed directly at our subject. The flash was set to full power and the light remained unmodified. The flash was sitting on a light stand and was triggered using an inexpensive radio-transmitter system.

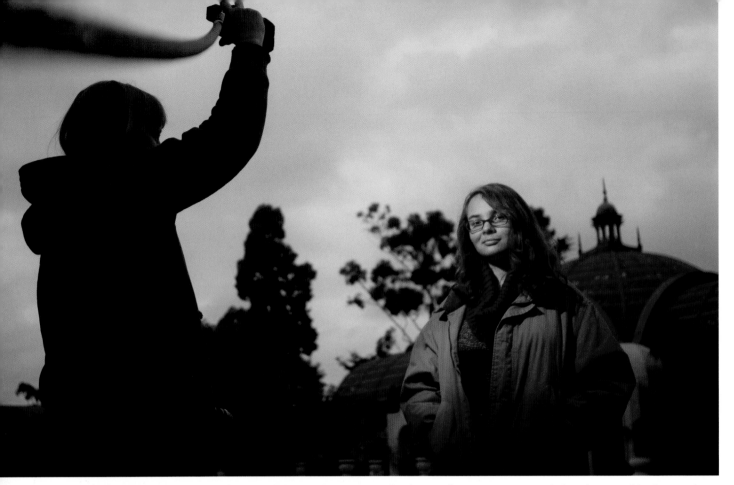

An artist begins with his background, dialing in the exposure that best makes it sing. Here, a darker-than-usual background was decided upon. Using manual controls, the photographer simply adjusted his aperture and shutter speed to make it happen. The consequence of this choice was a darker-than-usual foreground subject as well. This was fixed with the addition of light—held by an assistant. The flash power was adjusted to the photographer's taste.

The key to that transformation was his acceptance of responsibility. As a photographer, you have to take this upon yourself if you ever want to grow as an artist. If your picture is bad, it's because of something you did.

Going Beyond "Average." Your camera and flash, when in an automatic mode, have been designed to give you average (or "normal") images—but there is nothing average or normal about an artist's vision. If a photographer relies on automatic settings, his life and his images will be riddled with mediocrity. Nothing creative has ever come from a camera or flash set to automatic. Once again, leave the automatic settings behind and focus on your own experience and skills—instead of just another subject. "Average" and "normal" are nothing to aspire to.

Tip #1: Choose a Solid Base. Long ago, the International Organization of Standardization (ISO) created a formula by which film manufacturers could "rate" their film based on its sensitivity to light. Lower ISO films (50, 100, 200) were less sensitive to light than those that were rated higher. This allowed photographers a choice. We still maintain this choice; each

Here, both the camera and flash were set to automatic. As you can see, this rendered the scene just as it appeared—flat and boring. There is no drama.

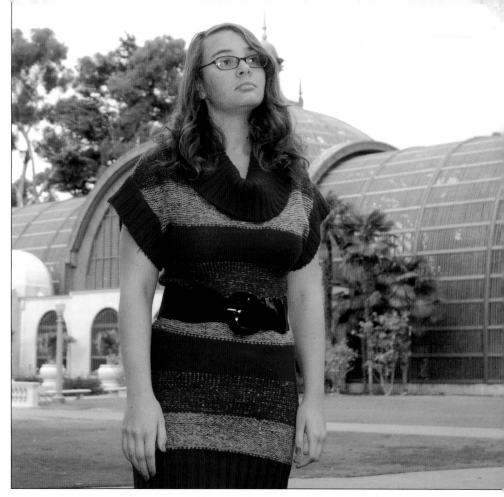

Using manual control, the photographer created what he saw in his heart. He then forced his camera and flash to do his bidding, creating an image that reflected his vision—not just the world around him.

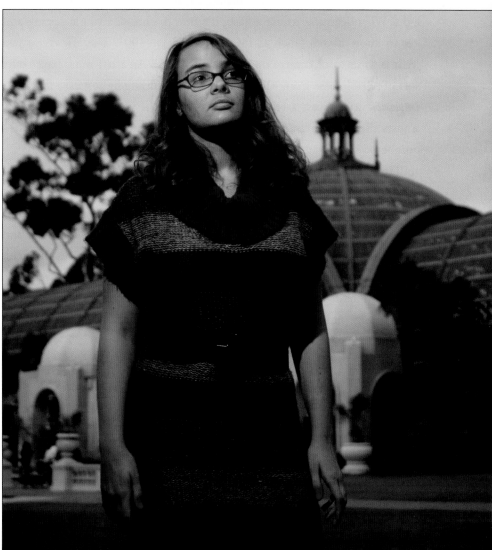

The modification of your external flash is a very personal thing—and no one tool will be perfect for every occasion. Many people enjoy the challenge of making these modification devices themselves. In the above images, you see the use of a homemade snoot and the effects it creates.

digital camera gives you the option of changing its ISO setting. While this adjustment does nothing physically to the sensor, it does ask the camera to mathematically alter the image produced, adding or taking away apparent light. When learning to use a flash, it's best to choose a single setting and get to know it well (such as ISO 100, 200, or 400). The last thing you want is to set your camera on "automatic ISO." An artist must have some sort of reliable base from which to work when adding light with a flash. It's *impossible* to forecast a result (gain experience) if your camera constantly adjusts the apparent sensitivity of your sensor. Our advice is to choose a numbered setting and get to know that well.

Tip #2: Don't Shoot in RAW When Learning. We find that shooting in the RAW format offers our students an excuse not to concentrate on some very vital parts of message-building. Shooting RAW files offers them a means of correcting their images after the fact, weakening their resolve and giving them an excuse for not creating a perfect image while in the field. As their instructors, that's not something we want to happen. Instead, we ask our students to make mistakes and learn from them while in the field—to fix things immediately and do everything manually. (This, as you can imagine, also eliminates most of the time spent at the computer—an added bonus!)

Admittedly, this is a different approach, but it's one that works well. It helps our students become the artists they want to be, carefully and

consciously dialing-in their own white-balance, contrast, saturation, hue, and sharpness settings *before* they create their message. If they were to shoot in RAW, those important options would be put on hold until they got home. When do you think you're more in touch with how something makes you feel—when it's right in front of you or a few days later, when you're sitting at home in front of a computer?

The Journey Ahead

What happens next is exciting. An amazing world of options will soon unfold—so will alternatives you've never seen and choices you've never imagined. You will learn to anticipate the impossible and demand perfection. Flash photography will change who you are as a person and what you expect to capture as an artist.

With enough practice, the addition of light will happen quickly—no matter what type of camera you choose to use. The key is allowing yourself to fail— then push forward and learn from each mistake.

By shooting in JPEG, not RAW, our students garner an insight into real message-building. Without the "crutch" of postproduction, they are forced to contend with their own weaknesses. The more mistakes they make, the more they learn while in the field.

2. Getting a Grip on the Basics: The Pop-Up Flash

With enough practice and understanding, the lessons learned when using your pop-up flash will blossom into a field of alternatives that have to be seen (and photographed) to be believed.

From Zero to Hero

Flash photography is challenging. No longer are you just *finding* the best light for your message, now you're intentionally *creating* it—taking one tier of graphic information and making it brighter than another.

LEFT—Much of what you need to know about flash photography can be learned from practicing with your camera's pop-up flash. Power settings, aperture considerations, and flash-to-subject distance all have to be accounted for and adjusted to your taste—even when using such a small light source. To get as much as you can from the experience, it's best to be in full manual control of your camera and flash. If you haven't mastered the controls for your pop-up, it's time to dig out the manual. The photographers shown in this image, and the one on the right, are training with a LumiQuest pop-up flash diffuser, a small modification tool that sits on the photographer's camera. RIGHT—The camera's LCD monitor gives you instant access to your mistakes, allowing you to grow as an artist at an exponential rate—one mistake leads to a different decision, which then produces another result.

In the top photo (made without flash), an aperture of f/8 and a shutter speed of $^1\!/_{100}$ second were chosen. The background is lit well, but our subject is lost in shadow. Choosing a slower shutter speed results in our subject being lit well but the background being too bright (middle photo). This is not a contrast problem; it's a tonal issue. The gap between bright and dark is too great for an internal contrast adjustment to fix. It's time to add some light. Returning to the faster shutter speed and adding light from the camera's pop-up flash (with the power setting adjusted to taste) resulted in a better image.

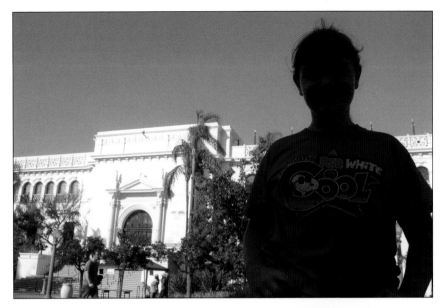

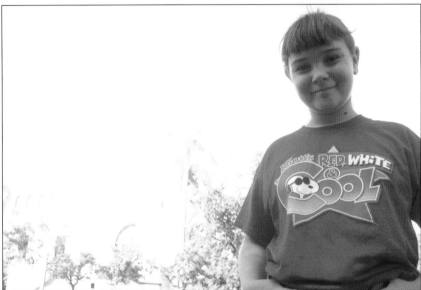

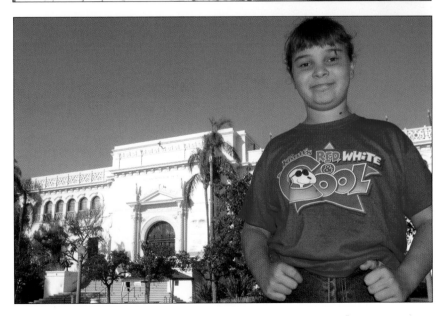

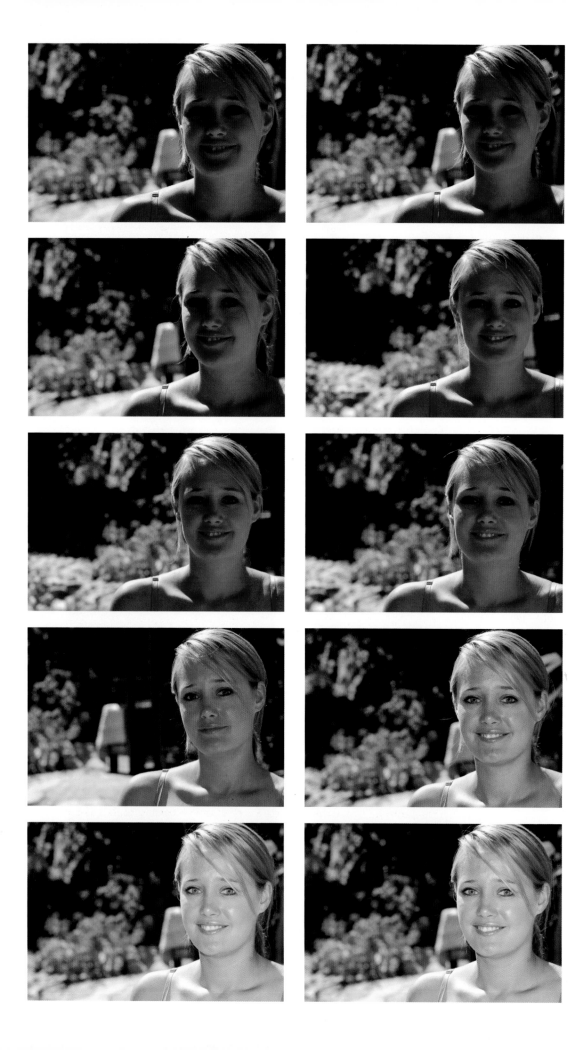

```
BUILT-IN FLASH
MANUAL

1/1 FULL POWER
1/2
1/4
1/8
1/16
1/32
1/64
1/128
```

ABOVE AND FACING PAGE—Most flashes, including your built-in pop-up flash, allow you to manually adjust the physical flash output. This is usually done in increments, which vary by camera and flash manufacturer. Get to know what your flash offers. These images illustrate the various "degrees" of lighting offered by a standard pop-up flash.

Try taking a few test shots—with the sole purpose of figuring out how much power the flash offers.

(*Note:* A tier of graphic information is any grouping of graphic elements—lines, shapes, colors, patterns, and tones—that speak as one unit. This could be a building, a tree, a house, a person, car, flower, or a fence.) This takes guts, this takes nerve . . . and it takes a solid understanding of the equipment you own. We suggest starting with your camera's built-in pop-up flash.

Getting to Know Your Flash

As with any new tool, it's important to get a feel for what this one offers. The pop-up flash is powerful and can emit a burst of light that will brighten even the darkest shadow—as long as that shadow is fairly close to the photographer. Obviously, there is a range issue when using such a small flash; it's not going to make it across a soccer or football field, but it can light up most everything close to the photographer—plants, people, cars, pets, and babies to mention only a few.

Using it well means more than just turning it on and pointing it at something nearby. There are power issues, diffusion options, and distance equations that must be thought of—each being just as important as the other. The nice thing is these flash options will remain the same no matter what type of flash you use. Everything you learn with your pop-up flash can be transferred to your work with external flash, whether it's attached directly to your camera or not. Every lesson learned here becomes a valuable resource and will give you the experience and confidence to push on with your flash photography.

Power Settings. Begin by reading about your pop-up flash in your manual. Learn how to manually adjust its power settings. Often, you'll be afforded the opportunity to vary its output dramatically. Each camera will have different ways to do this—and some are easier to find than others. Usually it's just a few clicks and menus away.

Try taking a few test shots—with the sole purpose of figuring out how much power the flash offers. Keep things confined and the natural light at a minimum. Use just the flash, turning it to full power and then slowly dropping the output. Your aperture and shutter should remain constant. Some cameras offer the ability to adjust the flash power setting from full power ($^1/_1$) all the way down to $^1/_{128}$ power.

Variable power settings are also something you should look for when purchasing any additional (much stronger) external flashes units. These will usually allow for the same type of power adjustments, using the same nomenclature ($^1/_1$ [full] to $^1/_{128}$) power. Keep in mind, though, that not all external flashes offer the same thing. Many give far fewer power settings to choose from and some may not offer any at all.

You can also use a reflector to add light to a subject. Relatively inexpensive, a reflector will kick back a certain amount of light if it's placed correctly. Usually, this requires having an assistant or an extra light stand available.

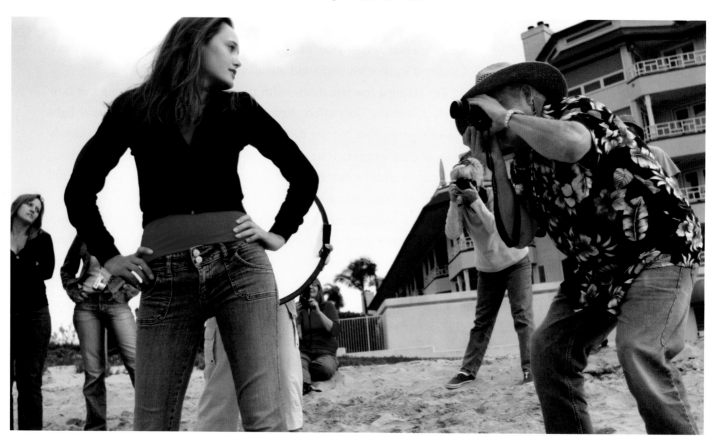

In your test shots, take note that a lowered power output does not necessarily soften or diffuse the light the flash is producing. It simply cuts the distance it travels. To truly modify the light, you will need to reflect it off of a surface or put something in between it and the subject; this will be covered later in the chapter.

The Aperture

There is only one way to directly affect the *actual* power output from your flash: adjusting the power setting of the flash itself. There are, however, several ways of adjusting the *apparent* output of any flash. You can alter the light directly by attaching various light modifiers that enlarge, contract, and diffuse it; you can adjust the physical distance between your flash and what it's hitting; or you can simply change the size of the aperture you are using. By shrinking or enlarging the aperture, the opening through which light passes on its way to your camera's sensor, you can give a "boost" to any flash—or strip its effectiveness completely.

With a larger opening (smaller F numbers), the majority of the light you are creating makes it to your sensor. If you use a smaller opening (larger F numbers), less light hits its mark. Imagine you are trying to fill up a gas can with a funnel over the opening; no matter how much gas you dump over the can, only a small portion will ever make it through the funnel. It's the same as when using a flash but shooting with a small aperture; the light is being produced, it's just not getting where it needs to go.

When smaller apertures are used, the photographer needs to remember to increase the physical output of his flash to compensate for this apparent loss. The problem for photographers using their pop-up flash is that it doesn't produce that much light to begin with—making the choice of very small apertures nearly impossible. Of course, there are always exceptions. If your subject is extremely close to the flash, then you may still have enough apparent power to light whatever it is you want. (And remember: this flash is still harsh and unmodified;

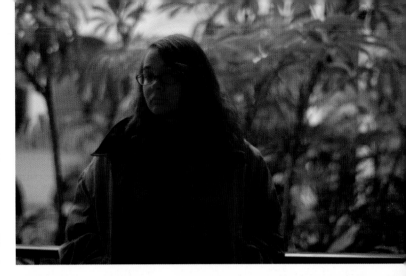

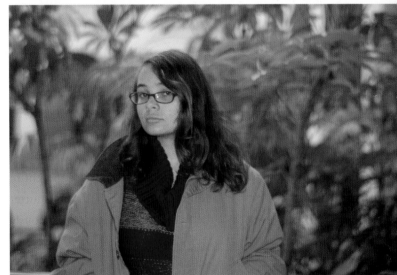

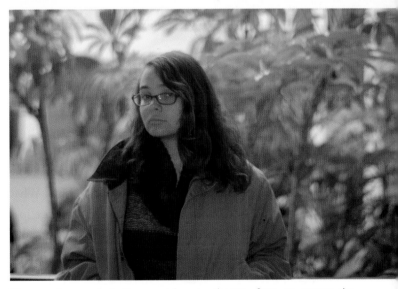

The aperture and shutter speed were chosen, first, to garner the background light (top). The pop-up flash was then added to illuminate the model (middle). Finally, the light was modified with a pop-up flash diffuser to soften the output (bottom).

GETTING A GRIP ON THE BASICS: THE POP-UP FLASH **27**

if you decide to modify it, that will further decrease the apparent output.)

Flash-Sync Speed

Flash-sync speed is an important concept to understand right from the start—even when using the pop-up flash. Most cameras today use a focal plane shutter. This shutter is made of two blades (or "curtains") that follow each other when the shutter button is depressed. The gap between the two blades is determined by the shutter speed chosen. At slower shutter speeds, this gap is large (often as wide as the sensor itself). At faster shutter speeds, this gap becomes quite small (smaller than the sensor itself). At these faster shutter speeds, the image is captured on the sensor as the narrow slit between the blades moves from one end of the frame to the other (usually horizontally). Think of it as if the camera is scanning the area in front of you. The fastest shutter speed at which the gap encompasses the entire sensor is called your flash-sync speed. At this shutter speed (or below), the entire sensor can simultaneously be exposed by the light from your flash. If you were to shoot at any speed faster than this, however, the burst light from your flash wouldn't hit everything within the frame; part of the frame would be hidden by the rear shutter blade.

To find your camera's flash-sync speed, simply adjust your shutter speed to its highest setting (either $\frac{1}{4000}$ or $\frac{1}{8000}$ second) and activate your pop-up flash. The shutter speed now given is your flash-sync speed; typically, it will be $\frac{1}{250}$ second or slower.

For pop-up flash work, the camera will not allow you to adjust the shutter speed past this point. What you should be concerned with, however, is your loss of options. By employing the pop-up flash, you limit the shutter speeds you can apply. For example, imagine you chose a large aperture to blur a background and that decision rendered a shutter speed of $\frac{1}{1000}$ second. Employing the pop-up flash would make your original vision impossible; the camera would slow the shutter speed to the flash-sync speed, letting in way too much light. Most photographers would simply compromise their vision and reduce the size of the aperture. Luckily, however, there are other ways to eliminate excess light—without ever touching the aperture.

Cutting the Light

As an artist, you should never compromise on your vision—especially if all you need is less light.

Neutral Density Filters. Through the use of several neutral-density filters, you can easily strip an image of light without changing the aperture. A neutral-density filter is a small piece of glass that screws onto the front element of your lens. These filters come in different densities and can be stacked one-upon-another until the desired amount of light is taken away. Neutral density filters are inexpensive and should be in every artist's camera bag. Not only do they allow you to keep your aperture where you want it, but they also give you a way of stripping ambient light and shooting with slow shutter speeds on purpose. Bear in mind, however, that this will have some effect on the apparent output of your flash, so you may have to increase the power setting to compensate.

Neutral density filters are one way of cutting excess light from an image. They come in a variety of densities and filter sizes.

The cross-polarizing technique is a highly effective method of eliminating excess light from an image.

Polarizing Filters. You can also employ a classic "darkening" trick that requires two linear polarizers. Simply stack two together and attach them to your lens. Then, turn the bottom polarizer to eliminate any excess glare and rotate the top polarizer to eliminate ambient light as needed. This cross-polarization technique works like a charm, giving you a variable neutral density that you have to put into action to believe.

Just as when using the neutral density filters, you may have to adjust the physical power output of your flash to offset the apparent loss of flash power when this technique is used. You will also have to be in complete manual control of your camera and flash for this trick to work—and you have to use the correct polarizers. In our experience, only two *linear* polarizers work; crossing a circular and linear or two circular polarizers will not give the desired effect. Usually all you will get is a very pretty color shift—which is useless when you want to spin your way to darkness.

You can also employ a classic "darkening" trick that requires two linear polarizers.

A Few Words About Contrast Settings

Shadows are a normal part of life. It's wrong to think that you need to "fill" these with light all the time. As a creative photographer, part of your message-building process is to adjust the camera's internal contrast settings before you take your picture. This, when coupled with the expert use of a polarizer, will usually take care of any heavy contrast present and "illuminate" anything that might be hidden by a pesky shadow. If you haven't played with this camera option, now would be the time. Use it, instead of your flash, the next time you're at the beach or in the snow. You will be shocked at what it offers.

Here is an example of what's offered through the use of the camera's built-in contrast options. The first image reflects the highest contrast setting available. The middle photo reflects an average choice, while the final shot shows what happens when a low setting is applied.

BELOW AND FACING PAGE—Did you know that a flash isn't always needed just because a shadow "seems" to be hiding detail? Often, this issue can be dealt with by simply adjusting the in-camera contrast setting. The below-left image shows what happens when the camera's contrast is adjusted to its medium (or normal) setting. The below-right image illustrates what happens when a polarizer is used while on this setting (notice the glare has disappeared). The image on the facing page shows the combined result of the proper use of a polarizer and a lower internal contrast setting. There really was no need to add flash to this image, even though it was shot at the beach in the middle of a bright, sunny day.

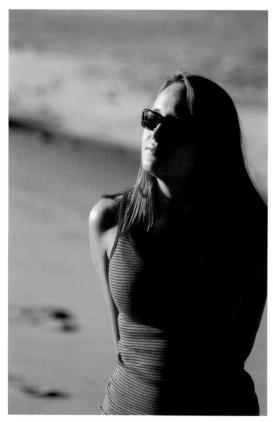 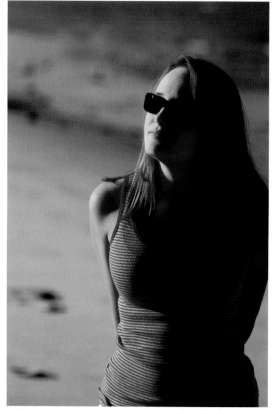

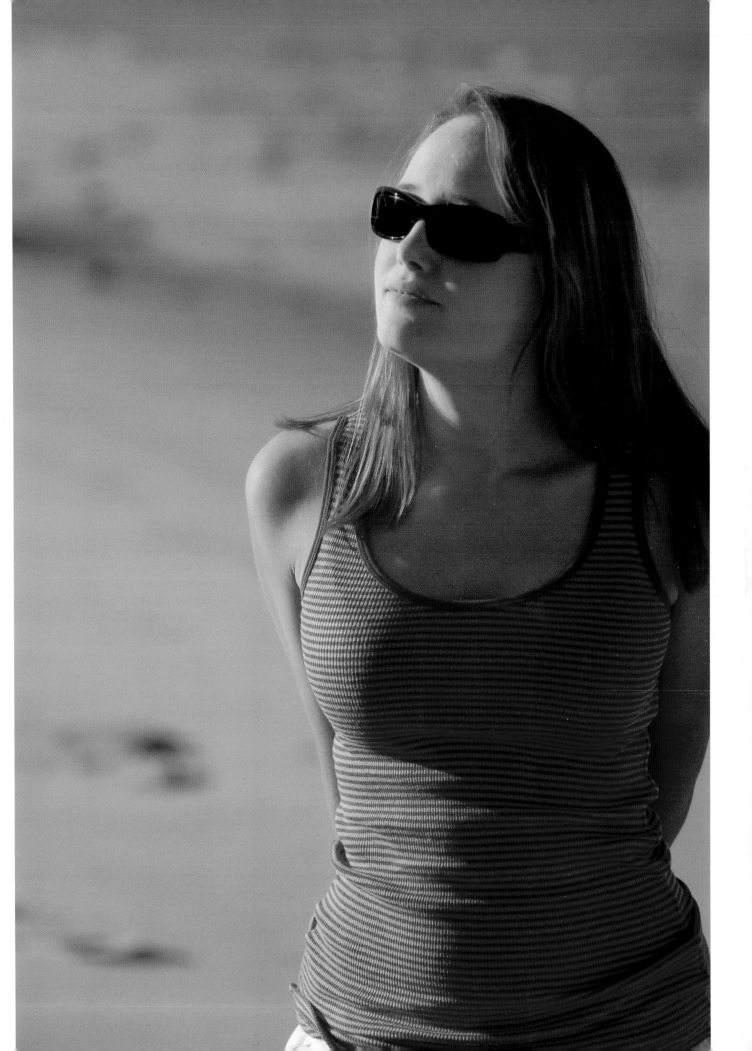

Light Modification

Light from a pop-up flash can be harsh when pointed directly at a scene or subject. Glare will be your nemesis. This is due in part to the fact that the light begins very small. Look at the physical size of your pop-up flash compared to a normal external flash and you will see what we mean. This concentrated power hits your subject quite hard, bouncing back into the camera's lens in a very unpleasing way.

Photographers have learned, though, that by enlarging the light, they can tame that unyielding power, spreading it out and diffusing it. This softens the blow immensely—and the larger you can make the light, the softer it becomes.

Commercial Products. You can purchase a pop-up flash diffuser that sits atop your camera (usually attached to the hot shoe), then wraps up and around to land in front of your flash. It's usually made of frosted plastic and provides a much larger light source—usually five to seven times the size of the original. The light produced by a device like this is much more flattering than the unmodified flash; the increased size and diffusion sees to that. Happily, the diffusers are also inexpensive and take up little room in your camera bag.

Do-It-Yourself Modifiers. Many photographers today like to make their own modifiers. The internet is full of very crafty people who have made an art out of designing flash modification equipment. Often, these

Light from a pop-up flash can be harsh when pointed directly at a scene or subject.

You have options when it comes to the pop-up flash. You can choose to adjust its power settings in the camera or you can modify the light it emits. Here, a LumiQuest modifier offers nice softness and diffusion.

Whether you make your own diffusion panel and attach it to your camera's hot shoe (as seen above) or simply grab a piece of tissue paper and tape it directly to the flash, you are going to want to modify the light your pop-up produces. Keep in mind that this does weaken the apparent output of the flash. When a modifier is used, larger apertures and higher power settings should be considered if faced with a loss of light that is unacceptable.

Breaking the Rules

Many great photographers shun the use of modifiers and use the resulting images to shock their viewers into submission. By playing against certain learned human biases, an artist can push society out of its comfort zone. Amazing explorers of light and the human condition, such as Diane Arbus, did just that. They broke the rules and didn't care if we liked or didn't like their images. They used a flash on-camera, shoved light directly at their subject, and never modified or bounced it. They lit their subjects the way they wanted—and as long as their true message and intent was illuminated well, they were happy. They believed, as many artists do, that just because everyone does something one way doesn't make it right.

As an artist, you too can be specific when designing your images and you too can make the decision to break from the norm. Keep in mind, though, that if you throw out the rule book when it comes to on-camera flash photography, you run the risk of people not liking your pictures. Societal biases are a strong deterrent to artistic expression—and our own desires to be liked do occasionally get in the way of creative freedom.

homemade tools create a light that can easily hold its own against the most expensive external flash units available today.

Making Your Own Pop-Up Diffuser. Often, a modified pop-up flash can be the answer to delicate lighting problems. Once diffused, the light it produces is actually quite flattering to a subject. Photographers have long used the softening power of a simple square of toilet paper for this purpose. This inexpensive tool not only diffuses the light, it also enlarges it—making it a near perfect accessory for your pop-up flash. Of course, you do have to walk around with a piece of toilet paper on your camera . . . and you will need to keep a spare square or two in your camera bag. In all honesty, though, the slight embarrassment is nothing compared to the startling diffusion power it offers. (In our experience, the best toilet-paper diffusion brand is Charmin's Ultra Strong two-ply. As shown in the images on the facing page, you can simply pull it apart and slip it over your flash. The Ultra Strong variety holds firmly in place, even in the strongest wind.)

ABOVE—With the proper modification, power output, and aperture choices, you can create a world of amazing lighting options using just a pop-up flash. It is a powerful tool and shouldn't be overlooked. Here, the photographer sandwiched two-ply toilet paper over the pop-up flash to diffuse the light.

FACING PAGE—Using a square of two-ply toilet paper to diffuse the pop-up flash.

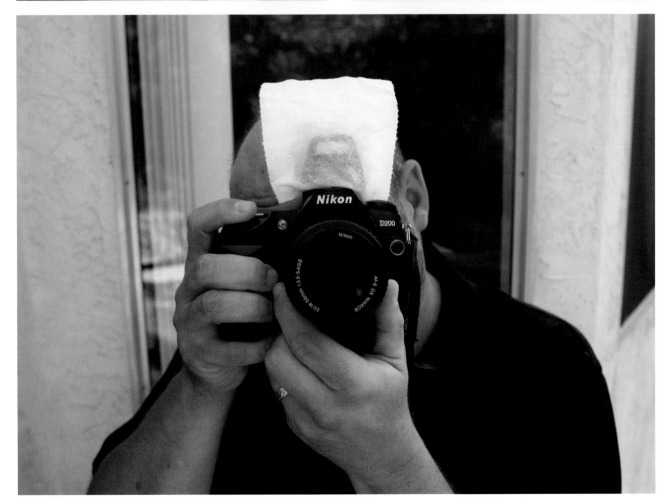

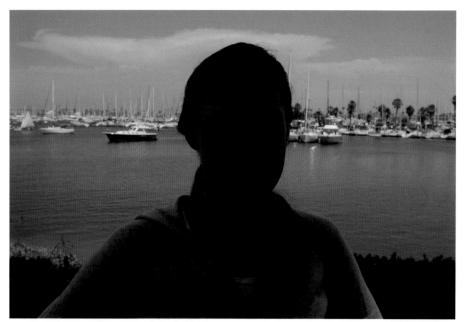

Again we see the effects of choosing a small aperture (f/10) and a shutter speed ($^1/_{80}$ second) to capture the background as we want it lit (top photo). Because our subject is in a shadow, she appears too dark. Adding light through the use of a larger aperture (f/2.8) resulted in a brighter subject and brighter background (middle photo). To illuminate our subject and keep the background intact, the aperture was changed back to f/10 and the camera's on-board flash was employed. To soften the light, a home-made (toilet paper) diffuser was placed over the flash. The effect is obvious; the light is soft and pleasing (bottom photo).

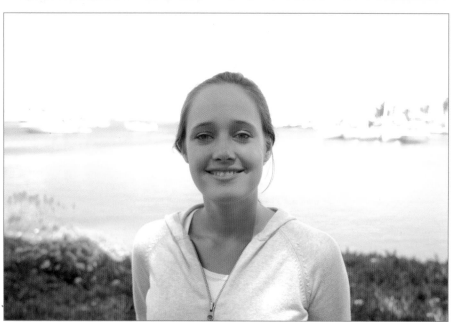

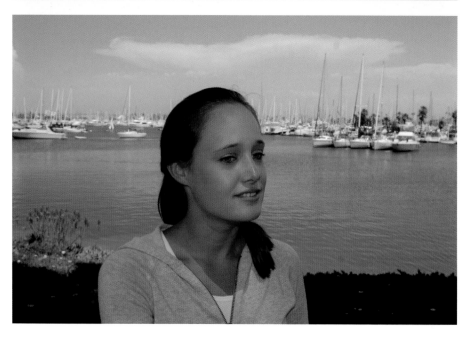

The above image shows a student using the scatterbox; the image to the right illustrates the power and eye-pleasing qualities that a good scatterbox offers.

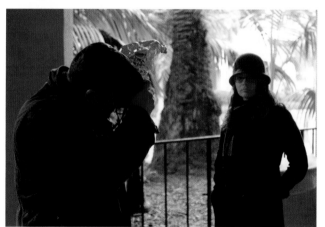

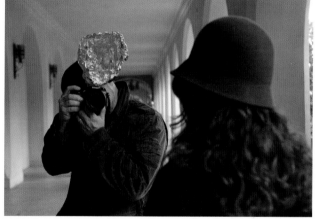

For gentle light, you need to create a very large scattering surface with your aluminum foil. The size of the scatterbox should be at least the same size as your camera.

Making Your Own Scatterbox. While it's true that your messages are your own and you can add light in any fashion you wish, human biases will dictate how easily your message is read. The pop-up flash, while an amazingly effective tool, also produces light from an angle we are not familiar with: straight from the viewer's point-of-view. This is not natural and is the main reason why most serious photographers don't use their camera's built-in pop-up flash. Fortunately, just as we dicussed, this light can be diffused and enlarged to make it a bit more agreeable. But there is an even better way of using the pop-up flash—a way of making that one small light source into

a giant (off-camera) light source that's handy, versatile, and flattering. It's called a "scatterbox." This home-made modifier offers increased size and a highly scattered light source—with little loss to the physical and apparent power output. Plus, the photographer suffers no ill effects from glare, since the light is scattering in multiple directions all at once. This simple tool can truly even out the odds in the worst lighting situations.

Unlike modifiers that simply diffuse or enlarge, a scatterbox lives up to its name, taking the majority of the light from your flash and scattering it in all directions. The light it produces evenly caresses anything it touches—no matter how close or far away your subject is; if the light hits it, it's going to

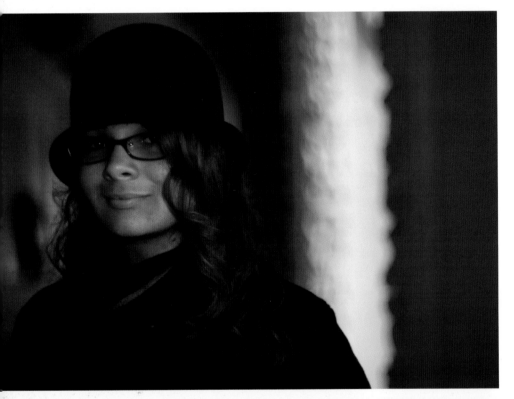

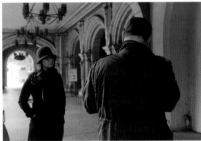

When creating your own scatterbox, you'll want to use a heavy-duty aluminum foil. Thinner foil tends to crumble under the pressure of photography in the field and doesn't take kindly to remolding.

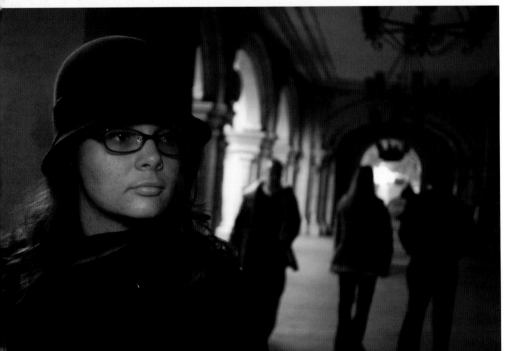

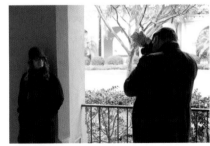

Keeping an extra piece of foil folded nicely in your camera bag gives you a quick way to create dramatic lighting.

Aluminum foil.

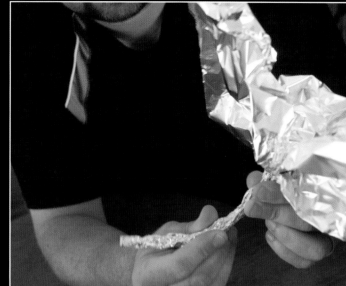

Six inches for the anchor.

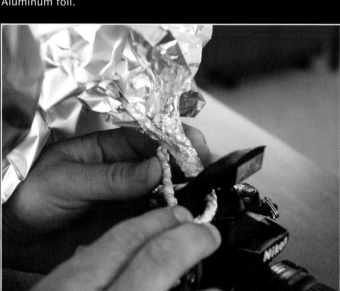

Wrapping the foil around the flash.

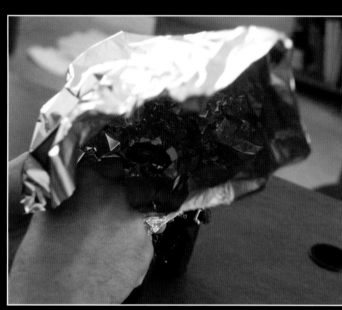

Building the reflector base.

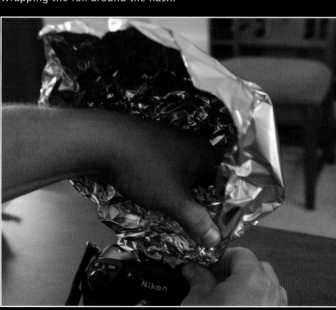

Molding the hood.

Fine-tuning the scatterbox.

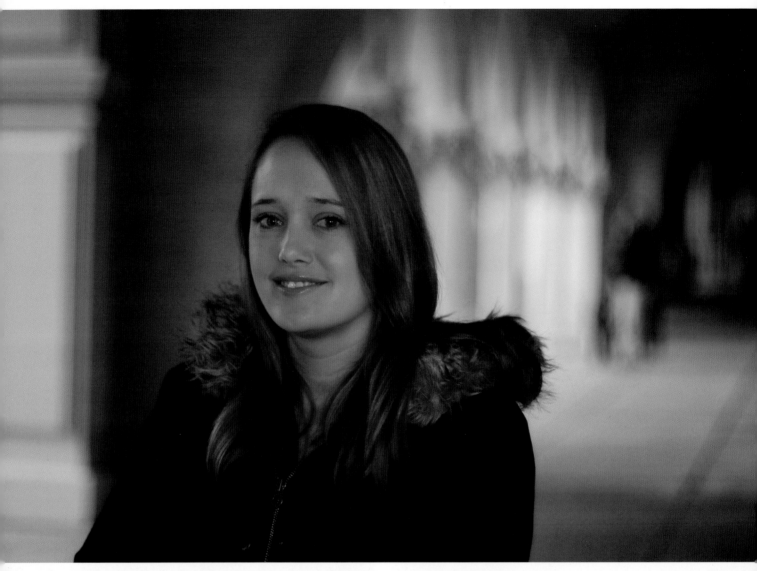

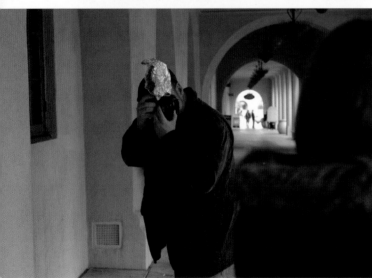

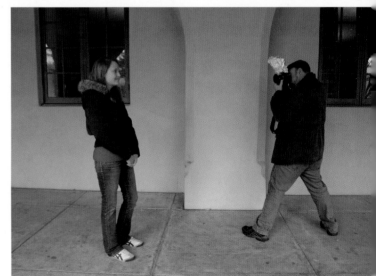

Since the light coming from a scatterbox is not diffused, only enlarged, you will not lose anywhere near the amount of power you do with other modification tools. Try bending the foil and aiming your flash at a nearby wall. This will enlarge your light source further, creating an even better and more intriguing light source.

Even when shot from just a few feet away—a scatterbox produces virtually no glare. This will come in very handy when creating indoor portraits of people who wear glasses.

Our cat Maggie is not much for photos and takes a great dislike to most flashes. However, the scatterbox is something she doesn't mind. Because of its large size and varied direction of light, it goes virtually unnoticed by her. The scatterbox also eliminates red-eye (or green-eye, in Maggie's case); without glare, red-eye can't exist.

look great. With a scatterbox, you'll even be able to shoot reflective surfaces, creating little or no glare.

To make your own aluminum foil scatterbox, we suggest using heavy-duty aluminum foil. Tear off a large piece and wrap the foil around the pop-up, anchoring it to the flash. You will then want to create a large bounce source near the front of the flash that directs the light upward toward another, much larger, bounce area. The idea is to bounce the light from the pop-up flash up into another reflective box which then shoves it out in all directions. It's an amazing tool when made well—and while you might not look "professional" when using it, your results will most certainly reflect your dedication to the craft.

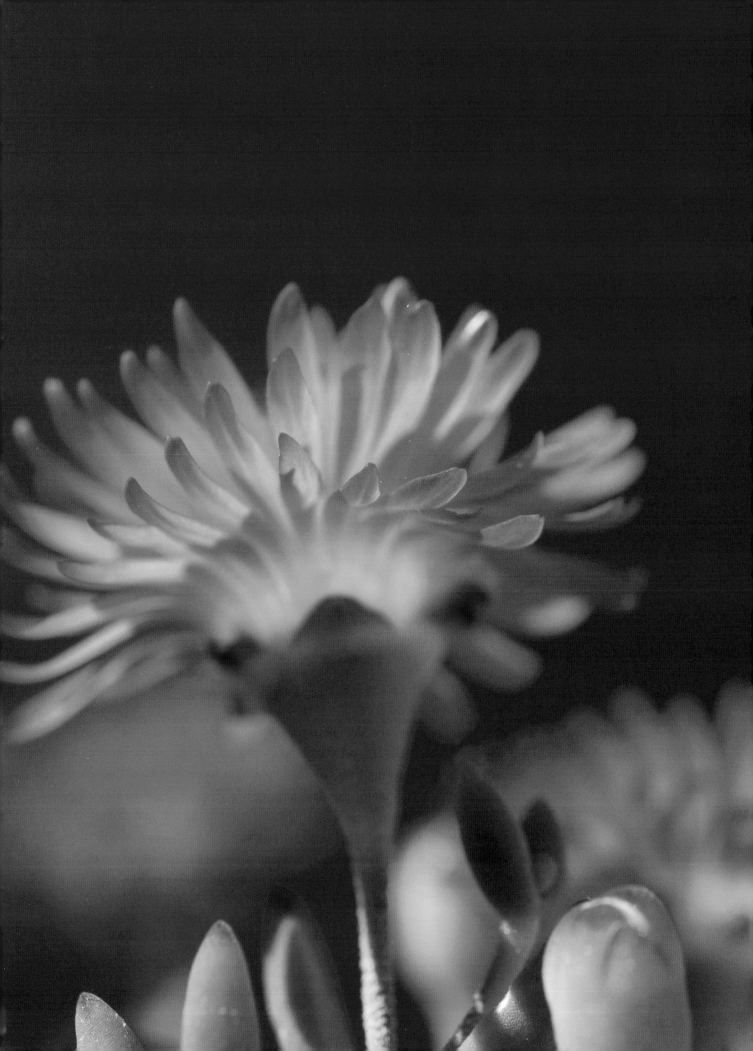

Two students tackle the challenges of working outdoors with a scatterbox, bouncing their flash off a nearby wall (bottom). The effects of the bounced flash are quite extraordinary (top).

FACING PAGE—In the hands of an artist looking for answers, the pop-up flash (with the right accessory—such as the scatterbox, as was used here) may give you exactly what you need.

Expect the first time you make a scatterbox to take a while. One of the toughest obstacles you'll cross is building the anchor; because of its large size, your scatterbox needs a firm base. You'll need to wrap the aluminum foil around the base of your flash tightly. From, there simply wrap the remainder of the foil around the base, in front of the flash, and back around to create the hood portion. Then, keep molding the scatterbox until it's perfect.

Close-Up Work with the Pop-Up Scatterbox. Macrophotography gets an added bonus when the photographer uses a pop-up scatterbox. Since the light is so large and scattered, it runs through your image and touches just about everything from the front of the lens to the back of the scene, no matter how aggressive the photographer gets with his power

With a scatterbox, the front of your subjects is lit the same as the back. Because the loss of light is limited, very small apertures can be used to maximize your depth of field.

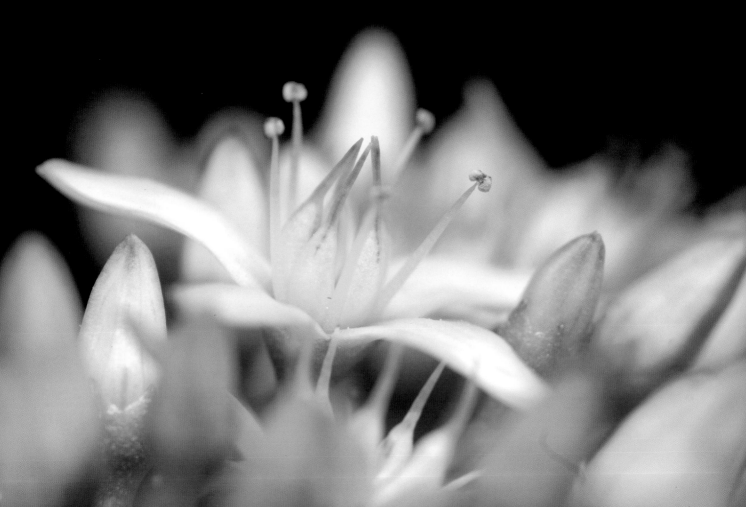

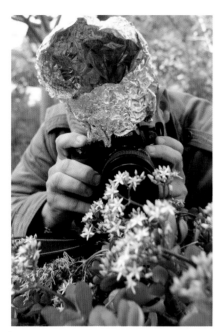

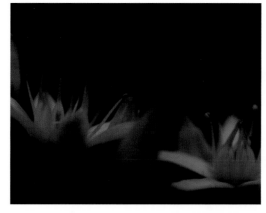
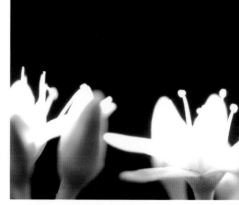

Above-left, we see how the scene appears if no flash is employed. The above-right image illustrates the severity of using the pop-up flash without any modification.

You may not appear all that professional when using a pop-up scatterbox, and people will undoubtedly look at you oddly. But keep in mind that it's the results that count—and there are no other pop-up flash modifiers that can come even close to competing with a well-made, aluminum foil, pop-up scatterbox.

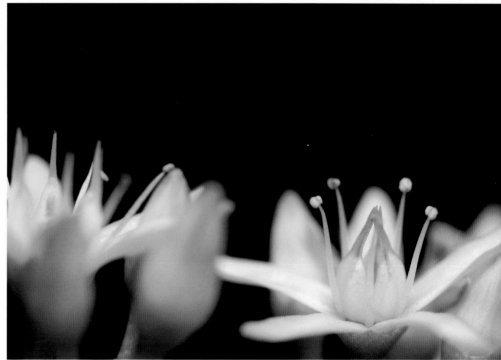

It's startling just how soft and pleasing the light from a pop-up scatterbox can be. If your scatterbox fails to live up to this standard, re-mold your tool. Usually it's simply stray light escaping from some corner or rip in the foil. Take your time when creating the scatterbox and pay particular attention not to allow any holes for the light to leak out of.

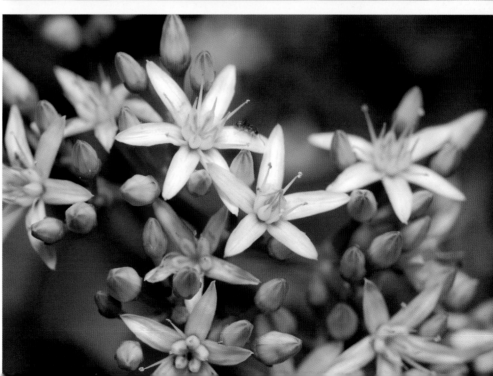

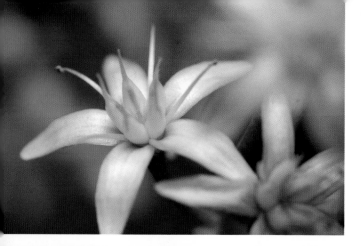

If your camera allows you to create in-camera multiple exposures, you'll love what the scatterbox affords. To create the dreamy image below, two separate exposures were lit by the modified pop-up flash. The top-left photo shows what the first exposure contained. Notice the blurry flower in the upper right-hand corner. This (as seen in the bottom-left photo) was then put into focus in the second exposure. Both were then combined by the camera itself (check your camera manual to see if it offers this magnificent option).The even and soft lighting could not have been accomplished without the aid of the scatterbox. While this effect could be mimicked in the computer, it means something special to be able to do it immediately when the idea strikes. (Besides, don't you have something better to do with your evenings than sit at a computer editing photos?)

Key Points for Chapter Two

To control the amount of light your flash produces, you have four options:

1. Adjust the power setting in the flash itself.

2. Adjust the distance between the flash and what it will be hitting.

3. Adjust the aperture; smaller apertures will not allow as much light into the camera as larger ones do.

4. Modify the flash itself. (In the case of the pop-up flash—the scatterbox, LumiQuest pop-up diffuser, and Charmin two-ply Ultra Strong toilet paper seem to work the best.)

And don't forget:

A. Adjusting the power on the flash doesn't enlarge or diffuse the light, it just changes the reach of the light.

B. You have a flash-sync shutter speed that you have to be aware of. Get to know what that is and try to incorporate this knowledge when building a message.

Scattered light produces little to no glare, while diffused light can.

settings. Keep in mind, as well, that the aluminum foil will kick out every drop of light your pop-up is producing; it's not diffusing the light, it's scattering it. There is a large difference. Scattered light produces little to no glare, while diffused light can. A diffuser, as you've learned in this chapter, will cut the apparent power output of your flash. A scatterbox won't. This is a major revelation for close-up artists. This means they now have a light source that provides even lighting, doesn't cost anything extra, and affords them the opportunity to use very small apertures when shooting things that are very close—a necessity when you want an increased depth of field.

3. External Flash

When the pop-up flash falls short, it's time to call on more power.

Without a flash, you are confined to the world of natural light, manipulating and adapting to "natural" lighting constraints. This doesn't mean your images will lack punch or that the quality of your message will wane, but it does limit your options. With an external flash, things are different. All of the "natural" rules of lighting go out the window and a new and vibrant set of alternatives shines forth.

Pumping up the Volume

Your options as an artist-with-a-camera climb with the addition of light from an on-camera external flash. The reach of the light increases, the coverage

It's important for the on-camera flash photographer to work with natural light, not against it. While the idea of eliminating shadows is admirable, shadows are an important part of life. It's not always necessary to destroy them. Through the use of specialized modification equipment (either home-made or store-bought), you can add just a touch of light to anything—not destroying the shadows but simply working with them.

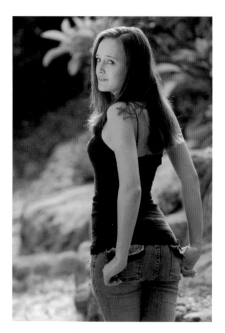
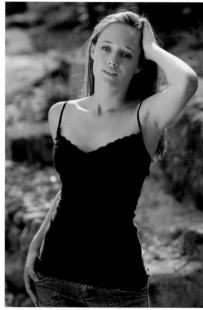
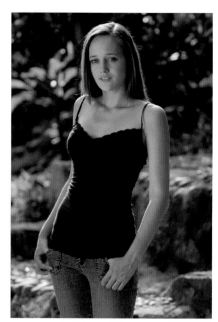

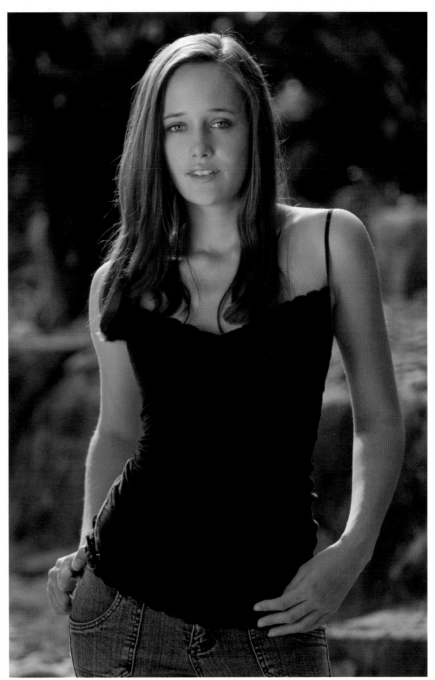

ABOVE—LumiQuest makes many different modifiers for external flash units. One of our favorites is the Big Bounce. This amazing tool not only bounces the light coming from a flash, it also diffuses it.
RIGHT—When using flash, it's not so much about the amount of illumination you're adding as it is about the quality of light you're producing. A large, diffused light source will create a more agreeable and pleasing light than one coming straight from a flash. In this image, a LumiQuest softbox was used to gently add light to the subject. By enlarging and diffusing the light, you can confidently use your external flash on-camera and expect good results.

extends, and—most importantly—the power to bounce light off walls and ceilings no longer rests with how well you can mold aluminum foil.

There are a few issues, though. The light from a camera-mounted external flash is harsh and direct. Additionally, it's still coming from the wrong direction; it's thrown straight at a subject—and now it's even stronger than the pop-up! Just like the pop-up, the light from this flash will have to be controlled if you hope to make your images more agreeable to viewers.

If you've never used a camera-mounted external flash, set something up that requires you to add light—as these images illustrate. In the top image, a shutter speed of $\frac{1}{125}$ second and aperture f/2.8 were used to tame the sunset. This left our model a silhouette. The on-camera flash was then engaged to brighten up the subject (bottom image).

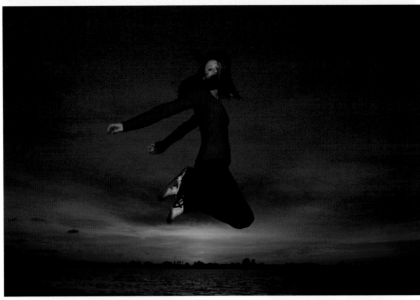

Changing the power on a flash is not that difficult a process. If the flash offers this option, you will be able to set the output in increments—going from full power ($\frac{1}{1}$) to its lowest possible setting (sometimes $\frac{1}{128}$).

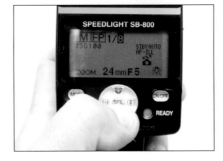

Power Settings and Angle of Coverage

You have several options when it comes to the power output of an external flash. The first is to simply adjust the flash unit itself. Just as the power on the pop-up flash is adjusted, you can adjust the flash's power setting from full power ($\frac{1}{1}$) to one of its other lower settings. Again, the power settings will vary by flash and manufacturer, but you should have a minimum of four choices ($\frac{1}{1}$, $\frac{3}{4}$, $\frac{1}{2}$, $\frac{1}{4}$). If your external flash lacks this basic option, it may be time for a different flash.

You can also adjust the angle of coverage of the flash unit. This gives you another method of increasing or decreasing the apparent flash output. Sometimes referred to as "zooming" your flash, this feature allows you to widen or narrow the beam of light that your flash unit produces. This is a pretty valuable option—not just for on-camera work, but for off-camera as well. Again, if your flash is missing this very basic option, it may be time to go shopping.

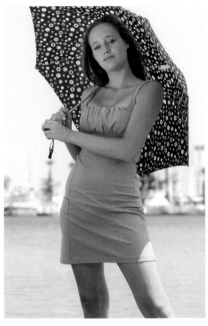

Being able to control the flash output is a major concern. Due to space limitations, desired perspective, or fast-moving subjects, it's often impossible to move back and forth to adjust the apparent power of your flash. Therefore, it's vital to be able to change this output at its source. Here, a very low power setting was used so that the light from the flash would merely touch the model, not engulf her.

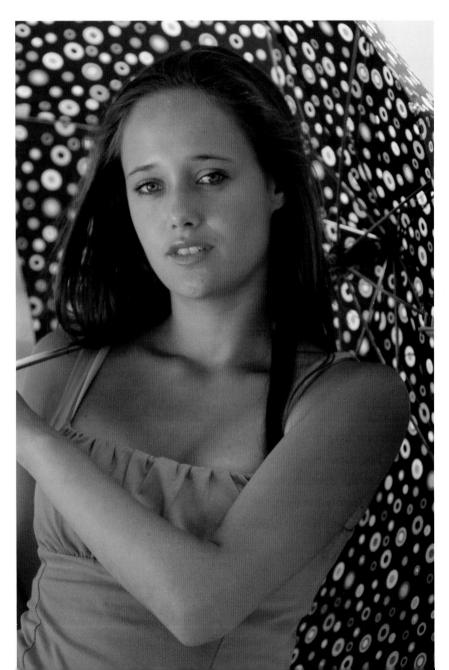

Part of mastering your flash means actually touching it. Spend some time with your manual looking for the power output and zooming capabilities of your flash. Then, learn how to adjust them quickly by hitting a button, turning a dial, or moving the flash head.

As a manual shooter, you will be able to use both of these features to adjust the distance your flash reaches, maneuvering each setting to match your vision. If you need more distance or more power, you'll either increase the power setting or narrow the angle of coverage, zooming your flash to reach the subject or widening the beam to pull it back. Both are strong options and you need to become proficient at using them.

We recommend that you spend several hours playing with each of these features. For these experiments, use a tree as your subject. With enough practice, you will develop an instinct for what settings will accomplish what. In your next outdoor session, test your knowledge by switching from a tree to a moving person. Try to quickly shoot a series of images with your flash,

If you need more distance or more power, you'll either increase the power setting or narrow the angle of coverage.

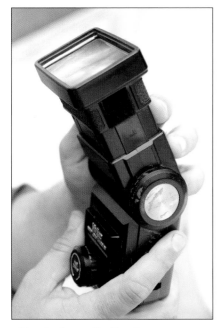

Older flashes will offer the same power and zooming options as newer units. The controls, however, are bound to appear different. If you're stumped, check the manual. If you no longer have it, then do a search on line. Most every manual for each flash can be found there.

adjusting both the power and zoom settings to keep up with your new target. It's challenging to say the least, but the rewards are far-reaching. With this newfound confidence, you will be free to move on to more complex situations and lighting problems.

The location of the power and zoom features vary by flash. On older flash units, you may have to extend the flash head itself to adjust the zoom feature. On newer units, the control can easily be found in the electronic flash's menu system. (*Note:* If you are planning on using an older flash unit atop your new digital camera, be wary of voltage issues. Older flashes use higher voltages than some digital cameras can handle. Be smart; check to see if the voltage is compatible before firing your flash on-camera. A fried digital camera is not a pretty thing.)

The power options can also vary dramatically depending on the age and brand of the flash. Some older flashes may even employ a color power scale, with certain colors corresponding to different power outputs. If using an older flash unit, make sure to find the manual; you'll want to become acquainted with its features (and, as noted previously, check its voltage output).

High-Speed Flash Sync

The use of an external flash brings with it another option—one that is as groundbreaking as it is useful. Previously, we discussed the limitations

On newer flash units, the power and zoom features can be found in the main electronic menu systems. Spend some time learning where these settings are. Keep in mind that if you're in any setting other than manual, you may not be able to access these very important creative features.

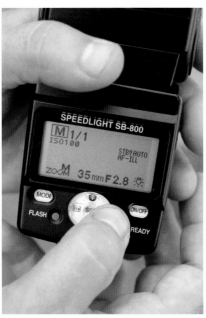
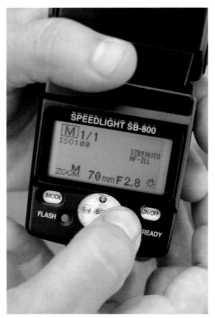
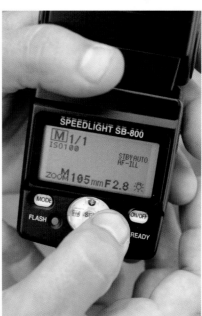

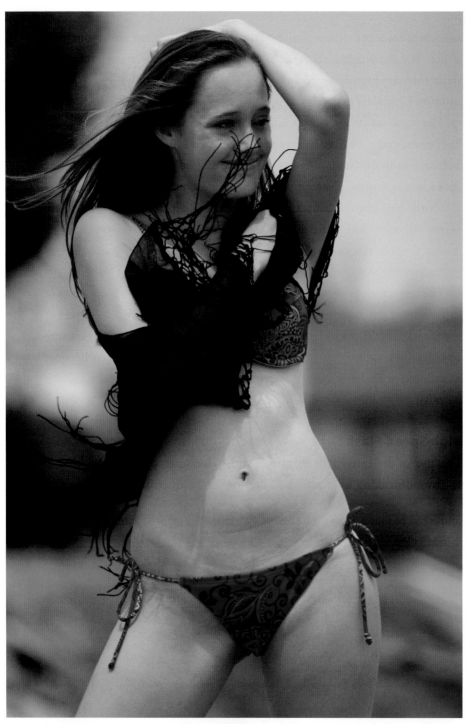

When the high-speed sync option is put into play, even more options become available to the forward-thinking flash photographer. These include unlimited depth of field choices and the ability to capture any type of fast action—no matter the ambient light.

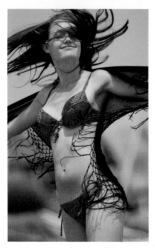

brought on by the camera's limited flash-sync speed (see chapter 2). Mentioned were two ways of dealing with this: the neutral density filters and cross-polarization.

Now, several camera/flash manufacturers offer a system that eliminates the issue of flash-sync speed altogether, allowing for unhindered flash work—as long as you use one of their special flashes. Nikon refers to this system as an FP (focal plane) mode, while Canon simply uses the letter H (High Speed Sync) on their flash to indicate this ability.

In high-speed sync mode, what the flash does is quite amazing. When a shutter speed above the camera's flash-sync speed is chosen, the flash emits several bursts of light, essentially filling in the gaps left by the traveling shutter blades. Thanks to this option, we can now shoot flash images with any shutter speed we wish—and without using filters.

This highly specialized option has its drawbacks, though. The higher the shutter speed chosen, the more the flash has to fire. These bursts are so fast that they appear as one solid flash, but they are not. The quick, multiple

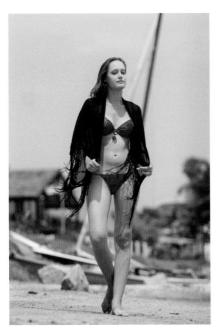

With the elimination of the camera's flash-sync speed limitation, your imagination can truly soar. In the images on this and on the previous page, we see the gentle caress of an on-camera, softboxed flash with the shutter speed set to $^{1}/_{1000}$ second—several stops past the camera's top flash-sync speed. The aperture was a whopping f/2.8.

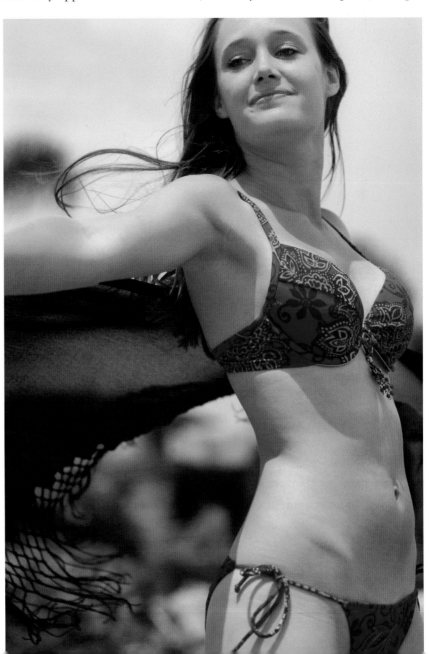

Using high-speed sync, photographers can freely choose the largest apertures they wish so that their backgrounds remain blurred and distant. The usual need to shoot with smaller apertures when a flash is employed disappears as your shutter speed options reappear.

bursts put a strain on the flash, resulting in less available power. This means that as the shutter speed increases beyond the camera's flash-sync speed, the power of the flash dwindles quickly.

Also, flashes that offer this option can get expensive. It's quite the proprietary system. If you own a Nikon, then you must purchase the Nikon flash that allows the operation. Canon owners will follow suit.

Light Modifiers

As most flash photographers soon discover, there is no power, zoom setting, or even fast-sync option that changes the real quality of the light. Turning the power up or down, making the beam wider or narrower, or firing off several flashes at once doesn't diffuse anything—it just changes the distance the light travels. As a result, all serious photographers who use a flash on-camera modify the light in some way. To soften your flash, you will need to add a tool that modifies or redirects the light you're producing—or get used to bouncing your flash off walls or ceilings.

Must-Have Modifiers: A Softbox and a Snoot. You can modify your on-camera flash in two ways. First, you can place something in front of your flash

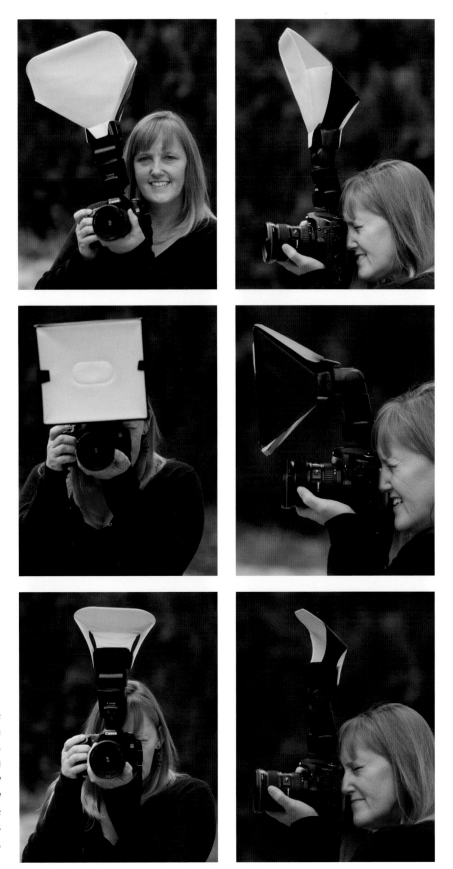

These are three of our favorite large LumiQuest modification tools. Each proved invaluable in the making of this book. The top two images show the Big Bounce. The middle two images show the SoftBox III. The bottom images show the classic Pocket Bouncer. For more information on these modification tools and other gear that we recommend, check out our gear list on page 116.

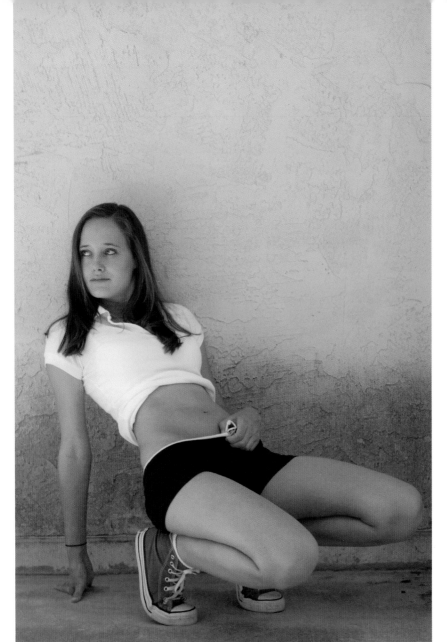

When introducing light from a camera-mounted flash, you will be producing glare. This glare, unfortunately, can't be eliminated through the use of a polarizer; it's simply coming from the wrong angle. In this series of images, a softbox mounted on the flash magically stripped the majority of the glare. The shutter speed, aperture, angle of flash coverage, and flash power settings were all set to taste.

that diffuses, softens, scatters, enlarges, or constricts the light. Second, you can bounce the light off of a wall, ceiling, or an on-flash modification tool designed specifically to bounce light. Which tool you employ will vary as much as the intent of your messages. Each offers its own unique set of advantages.

For the beginner, a softbox is usually a great place to start. We recommend these to all of our new flash students. This device simply sits atop the flash and both enlarges and diffuses the light it produces. It's usually made of plastic with a frosted portion folded down in front of the flash head. Softboxes are amazing tools and will make a huge difference in your on-camera flash work. The increased size cuts down on excess shadows and the diffuser panel helps fight the unwanted effects of glare.

Buy What You Need

Soft and gentle light, usually produced with a light modifiers, is *always* the way to go when the flash is on the camera. Otherwise, the additional illumination will call too much attention to itself and quickly drown out your original intent. However, there is nothing worse than having a huge collection of flash modifiers that never get used. You should only buy a modification tool when you know *why* you need it.

Another tool that will come in handy is a simple snoot. This modification tool compresses the light into a tight circle (or other shape, depending on the snoot), allowing you to direct a small pinpoint of light at your target. This will decrease the coverage area, of course, but it will also give an apparent boost of power to your flash. There is a learning curve involved here, depending on the snoot. You may have to go through a bit of trial and error to effectively direct the small beam of light. Snoots also create harsher shadows than those from a softbox. Still, a snoot is a fantastic option when just a bit more light is needed on only a small portion of your image.

Smaller softboxes often come in handy when the amount of light needed is small. The LumiQuest Mini SoftBox is a very versatile tool that creates pleasing, even lighting on both large and small subjects.

Snooting a flash is a fun way to explore your creative vision. The LumiQuest Snoot is designed to compress the light from your flash, yielding a smaller, much more powerful beam of light. This will take some practice to master, but it's worth the time and money.

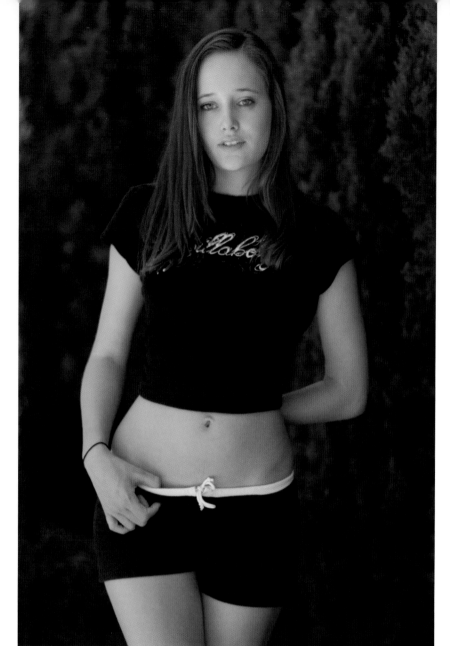

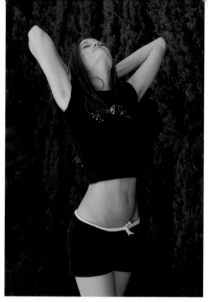

If you intend to create beautiful on-camera flash images, then the light *must* be modified. Left unchecked, an on-camera flash (no matter which power setting or angle of coverage is chosen) produces a serious amount glare. By attaching a light modifier to your flash you can soften the impact of this glare on the subject—sometimes (as shown in these images) eliminating the effects completely. Keep in mind, however, that when you enlarge your light source you are affecting the apparent power output. You will have to make the needed adjustments to compensate for this missing light.

Making Your Own Modifiers. There are many manufacturers of flash modification equipment—including softboxes and snoots. LumiQuest makes a variety of flash modification tools that we've trusted for years. You can, of course, strike out on your own and make your own equipment—after all, only you know what type of light your message needs. Not only is this approach fun, but there is a serious feeling of accomplishment when you know that your image could not have been created had it not been for your slightly modified potato-chip canister or the frosted three-ring binder divider you turned into a diffuser. (*Note:* Many flash-modification engineers share their inventions and insights on the internet. A quick search will afford thousands of modification ideas. In particular, the blog Strobist.com is home to some of the most dedicated flash photographers on this planet;

their insight and kind support have helped thousands of new flash photographers grow as artists. If you haven't checked out this site, do!)

Modification Problems. Be wary: as the size of the modifier increases, the amount of usable apparent flash power will diminish. You can make up for this "missing" light by choosing larger aperture settings, by increasing the power of the flash unit, or by zooming the flash head. You can also vary the distance you stand from your subject. Getting closer increases the apparent output of your flash; backing up reduces it. Keep in mind, though, that if you do choose these extreme options, your perspective, depth of field, and original intent may be compromised.

Bounce Flash. Bouncing light offers even more options when it comes to generating a pleasing photograph. By simply swiveling your flash head and pointing it at a wall or up to the ceiling, you are creating a very large light source that mimics natural light. Most photographers choose to modify their flash in this way since it requires no extra equipment and produces an even larger light source (resulting in fewer shadows and softer light).

When bouncing your flash off a wall or ceiling, the distance traveled to the reflecting surface must be included in your calculations of the power output requirements; even though your subject may only be six feet from your flash, the bounced light will have to

ABOVE—In order to bounce your external flash, it must be equipped with a rotating and swivel head. If your flash falls short on this, it may be time for a new flash. RIGHT—A gentle approach is needed when pointing your flash directly at a subject, but bouncing your flash off of a wall relaxes that requirement. Light coming from the side of something is seen as quite natural, giving you free reign to increase the power to your heart's content.

travel much farther than that to reach them. The surface texture of your bounce location will also play a role. A porous surface, no matter how rough, will scatter the light more effectively than a smooth one. Choosing the right surface will prove critical when creating a natural-looking light source.

The Importance of a Polarizer

Glare is *not* something that can be taken care of after the fact. Computer programs cannot strip glare from an image—this is impossible. You have

When you don't strip the glare (above), the results are not as pleasing as they could be with the addition of a polarizing filter (left). For polarization to work, you need to be at a 90 degree angle from the light causing the glare and you have to rotate the polarizer.

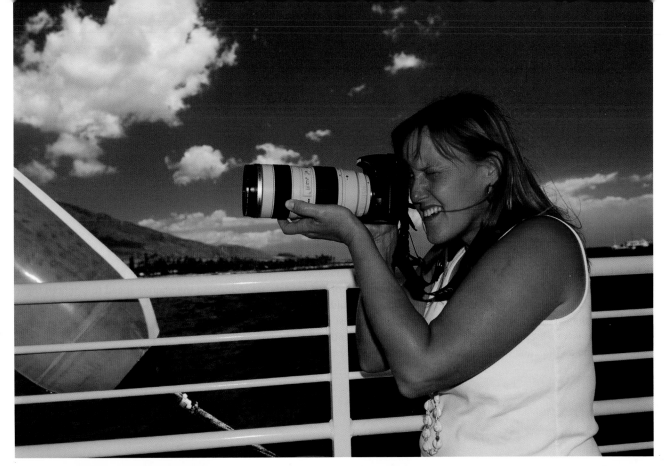

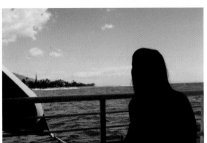

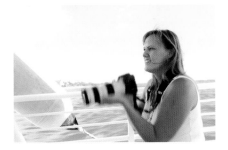

In the top-left photo, the photographer dialed in the lighting for his background, but since his subject was in a shadow, she appears dark. In the bottom-left image, you see the effect of dialing in a slower shutter speed. Even though our subject is now lit well, the background is too bright. The only way to capture this image well (with both the subject and the background lit evenly) is to use a flash. For the above photo, the photographer used the original settings (from the top-left photo), then rotated his polarizer correctly. Flash was added to illuminate the subject, but no other adjustments were made for the background; the striking difference is due solely to the polarizer.

to fix it before it happens. As a result, there is no tool more powerful than a polarizer when it comes to capturing amazing color. To truly grasp all of the creative options a flash offers, you must master this most basic photographic tool.

A Message-Building Process

As an artist-with-a-camera, your goal is to create an image that illustrates how you feel about something. We offer our students a simple strategy for creating amazing images with a flash.

Begin by adjusting your camera's white balance, contrast, saturation, hue, and sharpness settings. This way, there will be no need to adjust anything after the fact. (If you practice enough, this will become just as natural as changing lenses.)

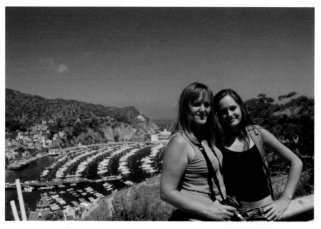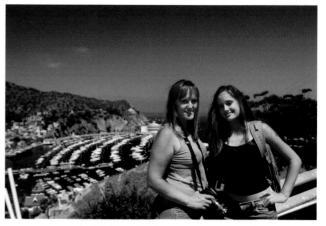

In the left photo, an aperture and shutter speed were chosen that allowed for the lighting and depth of field seen. A polarizer was also employed to enrich the colors. Notice how dark the faces of our models are. Adjusting the shutter speed to brighten those shadows would have a serious side-effect: the background would also gain light. Changing the in-camera contrast setting would compromise the blazing-rich colors in the background. The best option was to add light with a flash. In this case, the power and zoom settings were then dialed in and the flash was modified with a softbox. The right image shows the result. Message-building is about having a vision and not letting anything get in the way.

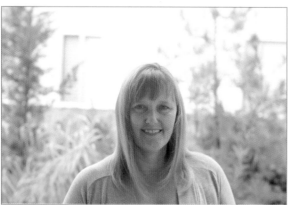

Begin by dialing-in the light for the background, adjusting the shutter speed and aperture until it looks just right. This gives you the base light. From there you can decide what needs light and how much it will require.

You cannot change your camera settings without compromising your original intent. This image shows what happens when the shutter speed is slowed to add light on the subject.

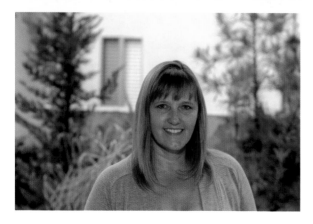

With the original settings reapplied, a softened (modified) flash was added to the shot.

Next, choose a location from which to shoot. This decision will be based on a desired perspective. This is very important, since it's this distance that dictates how each graphic element relates to one another in terms of size.

Once your shooting location has been chosen, the lens required will be obvious. The focal length simply reflects your desired crop factor. The aperture will then be picked based on the needed depth of field; the shutter speed will be based on how you want your message to be lit.

The next step is where all the magic happens. If, under your current set of requirements, natural light just doesn't afford you the illumination you want, then change it. Add light with your flash.

Using Your Flash at Night

Even when the sun sets, you still have to play by the rules. In the inset image, we see what happens when the camera and on-camera flash are set to automatic exposure. The large photo shows what happens when the photographer manually dials in his exposure using a very slow shutter speed to bring out the background, then fires his flash to brighten his foreground subject. Again, the photographer worked from the back forward, taking care of the background (areas the flash couldn't touch) with his aperture and shutter speed, then lighting his subject with the flash. This is real message-building. It will change your life and your images.

Using a flash on-camera gives you a great opportunity to maintain the detail of close tiers of graphic information. In this image, both our model and the foreground plants received a splash of light that helped bring the detail to life. A smaller aperture (f/9) was chosen to help with depth of field and a fast shutter speed ($^1/_{250}$ second) was picked to help maintain a rich sky and frozen model.

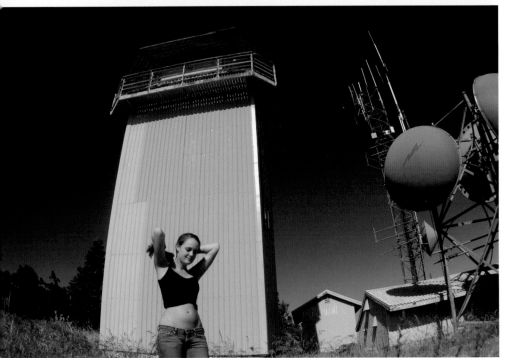

LEFT—When using a wider-angle lens, be wary of any distortion it may cause. Here, you can see a severe curvature running throughout. While it proved an effective tool in these particular images, that may not be your intention when creating your messages. Look carefully through your viewfinder. If you don't like what you see, change the lens.

BELOW—With the polarizer turned and a smaller aperture chosen, all that was left was to add a touch of soft, modified light to our model. Here, a small softbox bathed our model, never once overpowering her. One of the key goals when using a flash on-camera is to make it look like you didn't.

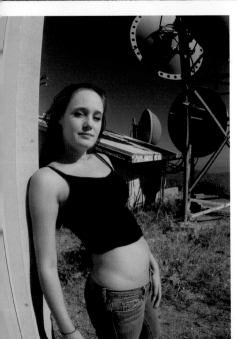
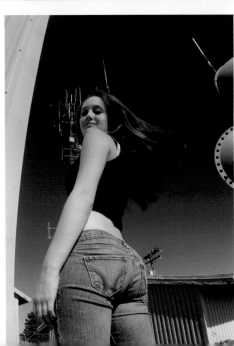
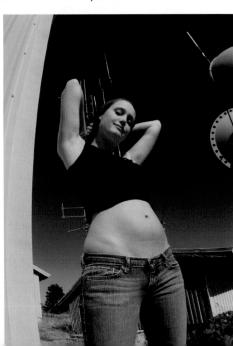

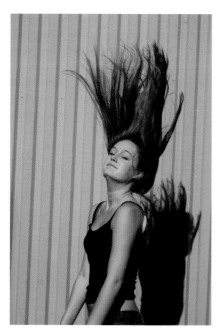 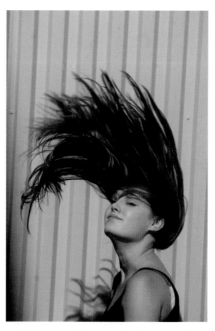 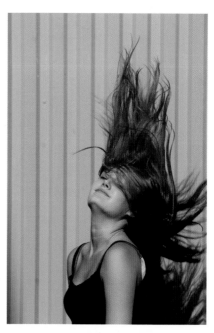

In the above images, you can see how—even with the introduction of light with a flash—the shadows on the wall behind our model never gave the secret away. The key to using on-camera flash is to keep it large with the help of a modifier and to keep it close to your subject. The bigger and closer your light is to your subject, the fewer and less harsh your shadows will be.

More than anything, remember to have fun with your camera, flash, and friends. Keep everything light and carefree, and your images will show the joy of the moment and the spontaneity of life. Staging your images will stagnate your view of both photography and what it means to call yourself a photographer.

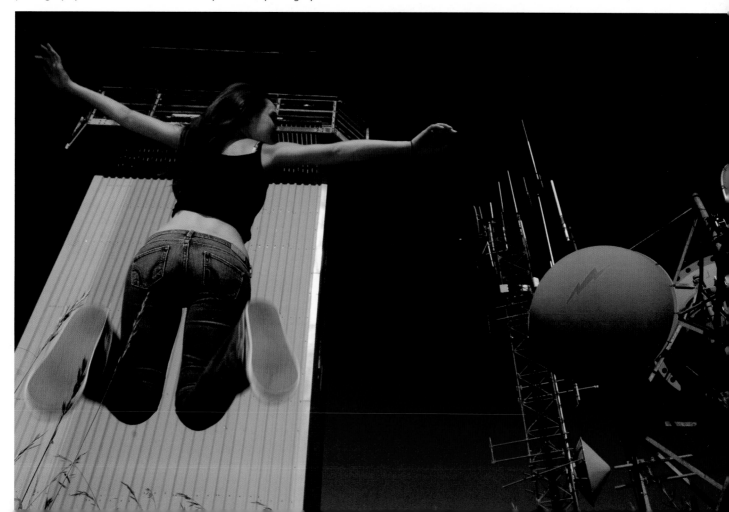

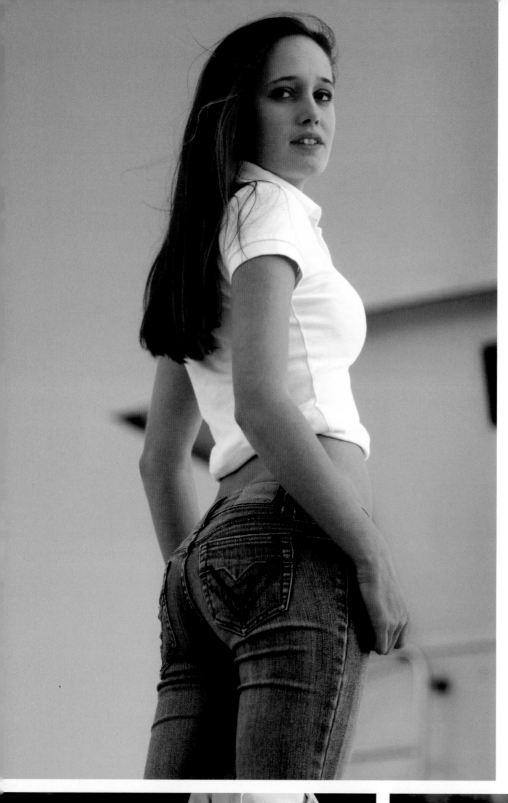

When using a flash mounted on your camera, a gentle approach is needed. Don't put a stranglehold on your background with too bright a subject; the light simply needs to caress your subject, not overpower it. In this image, a LumiQuest softbox was used to gently add light to the subject.

BELOW—You can, of course, simply shrink your aperture to strip any excess light. This will have an extreme effect on your background, keeping most of it in sharp focus. As these images illustrate, sometimes that works out to your advantage.

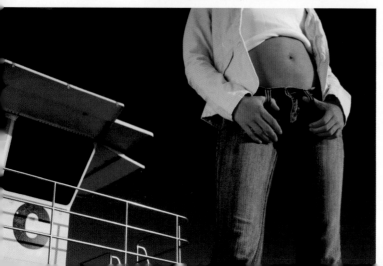

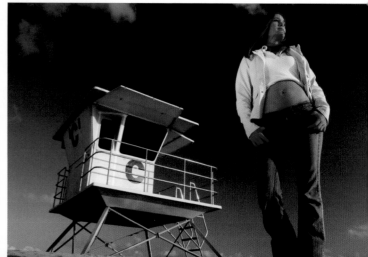

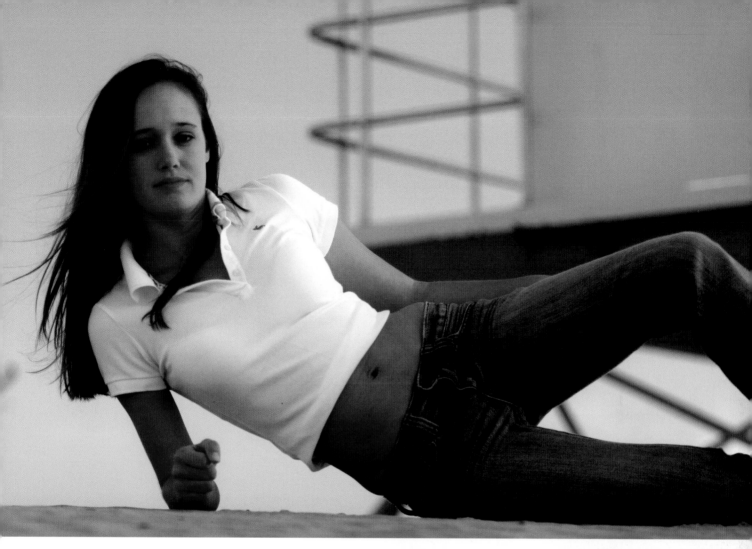

Larger apertures produce blurrier backgrounds, that's a given—but with this larger aperture comes the potential for blowing out your backgrounds if you can't overcome your camera's flash-sync speed. Remember, you have several choices for eliminating excess light: you can use the cross-polarization technique; employ several neutral density filters; or purchase a camera and flash system that offers the high-speed sync option.

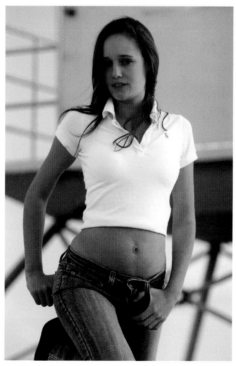

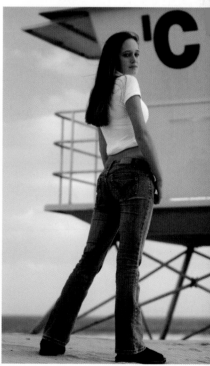

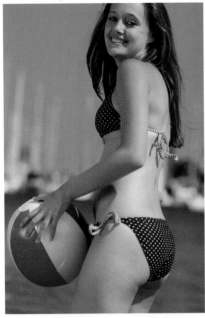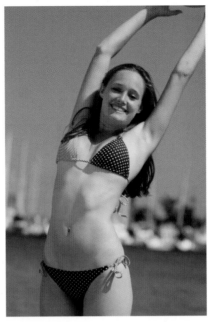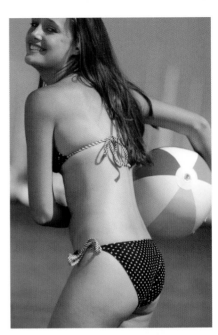

To achieve the blurry background, a larger aperture (f/2.8) was chosen. This, in turn, called for a fast shutter speed ($^1/_{1000}$ second). The high-speed sync option was then called into play to keep the aperture and shutter speed settings where they were.

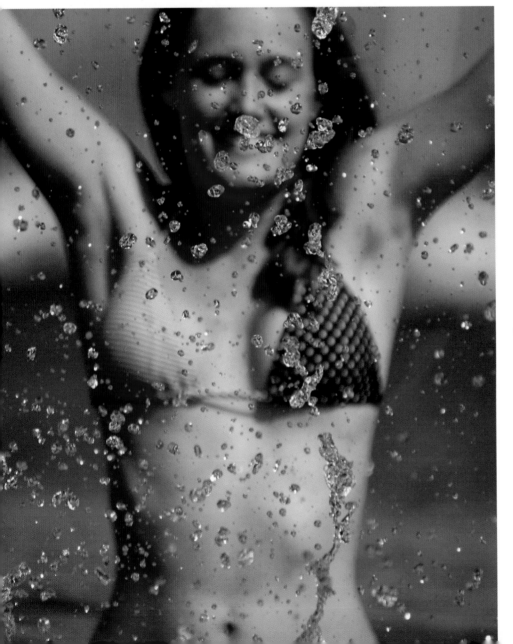

LEFT—Even though the modification and high-speed sync option cut the apparent power of the flash, the larger aperture balanced out the equation, offering just enough light to bring our model and her splashes happily out from the shadows. FACING PAGE—Using a large, modified light source on-camera will keep things light and friendly during your photo shoots. Without the harsh flash, your models are more likely to relax and just have fun. In this series of images, the LumiQuest Big Bounce was used.

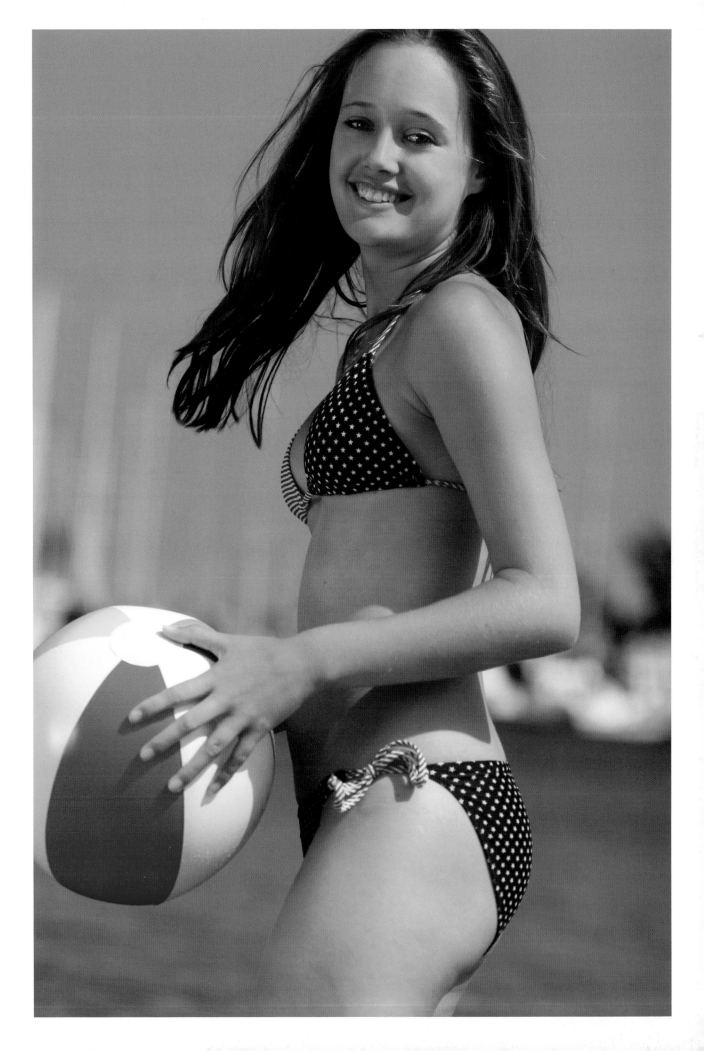

 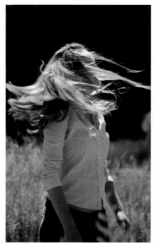 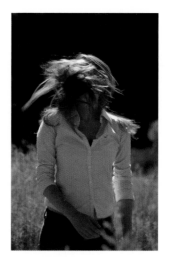 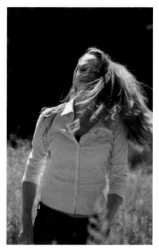

Key Points for Chapter Three

With the introduction of an external flash, you gain two possible new options for controlling the physical and apparent output of your flash. You can now use the flashes' zoom feature to increase or decrease the distance light from the flash will travel. Widening the spread will weaken the blast, while narrowing the beam will gain a considerable amount of travel distance and apparent power. You can also employ the high-speed sync option that many newer flashes and cameras offer. This gives you the option of shooting at any shutter speed you wish, never compromising your vision because of simple mechanics.

1. Learning to control the power and zoom settings are important to achieving precise control over your results with an external flash used on camera.
2. Opting for a camera/flash system with high-speed sync will increase your creative options and control.
3. Unless you like your images to look like you shot them with a flash, you will need to modify the light source—diffusing, scattering, compressing, or bouncing your way to better images.
4. Designing effective images relies on a process of message-building. This means making conscious decisions about your camera settings, perspective, and lens selection, then working from the background to the foreground when considering your lighting options.

ABOVE—Power output will affect the recycle time of your flash. If you're planning on creating a series of quick images using your camera's motor drive, it's best to use a lower power setting on your flash; this will allow more shots using less battery power. A larger aperture can also be employed to help regain some of the missing light the lower output causes.

4. The Wired Approach

Taking your flash off-camera opens the door to even more creative possibilities—and tougher challenges. Communication and support issues will quickly rise to the forefront of your message-building process.

The wired, off-camera flash option provides an ultra-reliable and inexpensive way of triggering your flash. Of course, every rule you've learned so far about power output, flash diffusion, and distance variables still applies—but now you'll have to translate all of that into a flash that's three feet from your camera.

Taking your flash off-camera frees you to explore your imagination and creativity without fear. No longer shackled to a hot shoe, you will find a new set of options waiting—and a unique (and rather simple) way of

An off-camera flash can be used to mimic the sun, lighting your subject from an angle that appears natural. Here, it all started with the background. To achieve the extreme blur, a very large aperture (f/1.2) was chosen. This allowed a lot of light into the camera, so a shutter speed of $^1/_{2000}$ second was chosen to keep the background from overexposing. A dedicated TTL cord was used to connect the flash to the camera, allowing the flash's high-speed sync option to be used. As you can see in the setup shot, the flash was held by an assistant who extended the TTL cord to its maximum length. This ensured the best angle from which to attack the glare with an on-camera, lens-mounted polarizer.

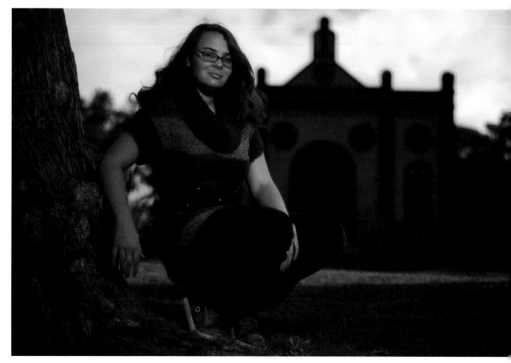

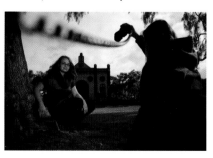

You're Ready for This!

With the help of your pop-up flash, you've hopefully deciphered what it takes to control flash output. You understand how aperture choice plays into flash photography, and how enlarging, compressing, diffusing, and scattering light can help. With the aid of your on-camera flash, you've also learned how to focus that beam of light by zooming the flash head. You've practiced bouncing your flash off of walls and ceilings and have even employed some form of modification—such as a softbox, snoot, or bounce tool—to your flash. If you haven't made it this far, you may want to rethink your strategy before progressing any further. It's important to have a firm grasp of the basics before attempting off-camera flash work. If you need to practice more, do it.

exploiting them. Just stretch out your arm and light the world as you see fit, changing each graphic tier to match your own vision.

Beginning Again

Just when you think you've got everything licked, something new and better comes along. While the modification options available for on-camera flash allow for some pretty spectacular images, it's not until you take the flash off-camera that the true magic of using an external flash unfolds. Using an off-camera flash will give you the best possible options. It will also challenge you like nothing else ever has. It requires ruthless determination to master, so you will either use it well and make it part of your regular message-building repertoire . . . or you won't use it at all. There is no middle ground when it comes to full creative freedom; you either want it or you don't.

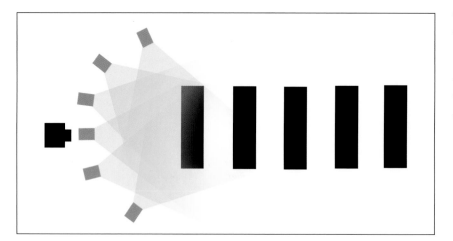

The real options begin when you take the flash into your own hands—literally. By simply hand-holding the flash, you'll now be able to make subtle changes to the light's angle and direction, options that are impossible when the flash is attached to the camera.

Taking Control

Few photographers grapple with this challenge for real; most allow the camera to make some of the decisions for them. Little things (like the amount of light their image receives, the colors their photo favors, the depth of field, the angle of coverage, the flash's output, and even what their lens focuses on) are given away to the machine. Exactly what part of that is art? Where is the pride in creation when all you do is press a button and point a camera?

Despite what camera manufacturers will try to tell you, there is no shortcut to creativity. There is no automated mode or flash system that will produce artful images. A machine, no matter how expensive or advanced, can *never* know what you (the artist) want to say or how your image should appear. You'll have to have some faith in yourself and your vision to make it through. More importantly, you'll need to stop relying on that equipment to speak for you.

Giving away any of your artistic choices kills the real pride in creating a message. Sure, it's hard to control all of these things at once, to think beyond simply reaction—but anything worthwhile is worth working for. Fortunately, the rewards come quickly. You'll make some mistakes, but your experience will grow with each one—and, before long, you'll be taking full advantage of the fantastic options that only an off-camera flash affords.

LEFT—The creative freedom and lighting options offered by simply moving your arm around are tremendous. When purchasing a flash cord, make sure you get one that's at least five feet long—often you'll have family or friends hold your flash. This we promise.

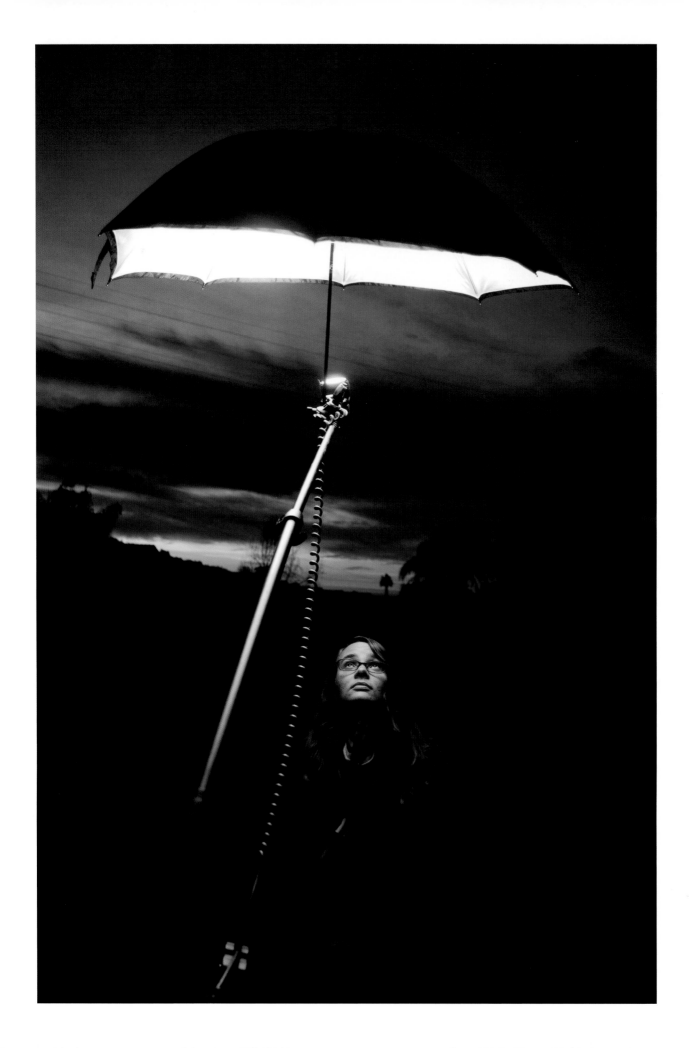

FACING PAGE—The wired approach can be taken to the extreme with the help of a hand-held "flash stick" (a light stand with its base broken off; see page 99 for instructions on how to build one yourself) and a reflective umbrella. This is one powerful combination. ABOVE— Here, a group of students tackle the task of learning to use their flash off-camera through a corded approach. While it may feel a bit awkward, your messages and your true intent will shine because of it. Off-camera corded flash work is a very personal way of adding light; you begin to feel more a part of the creative process, since every small movement of your wrist brings new and exciting options.

Supporting the Flash

Taking the flash off-camera brings with it its own set of unique consequences. One of these is finding a way to hold the flash in place. There is no real trick; just grab the flash and point it at something. You will have to develop some sort of consistent system, grasping the flash in one spot only and keeping your wrist angled in one direction only. This should take a matter of 45 minutes or so to master. You'll also have to get used to stretching out your arm and holding it still.

Be prepared: hand-holding a flash is a little awkward and will result in failures and bad images in the beginning. With time and patience, however, your skill will grow. Explore the dangerous, learn to add light by simply directing it with your hands. So stretch out your arm and start practicing— you'll be amazed at the results.

Communication Issues

You will also need a way of triggering the flash. This simply requires a cord that runs from the camera to the flash unit. There are two types of connections available: one takes advantage of your camera's hot shoe; the other uses your camera's PC terminal.

The PC terminal is quickly spotted on this camera; it's the protruding circular object on the top left side. Notice the connection pin in the center. (Keep in mind that it is quite possible that your camera may not have a PC terminal.)

The PC sync terminal is hidden/protected on this camera. Lifting the rubber flap reveals it. Notice that it also reveals other ports; don't mistake these for a PC terminal. Digital cameras often feature video-out terminals, USB connections, and even audio jacks.

A PC Connection. Let's begin with a straight PC connection between camera and flash. (*Note:* The "PC" acronym stands for Prontor/Compur, a standardized connector for linking two electronic devices.)

First you'll need to know what you have as far as connectivity goes. Take a close look at your camera and flash, search for the PC terminal. This connection is a small circular electronic "hole" that is usually found near the bottom or top of the camera. Precise locations vary by camera manufacturer. The PC terminal is usually pretty easy to spot—although sometimes it will have a plastic or rubber hood covering it.

Your camera and flash may have other electronic input and output devices as well. Don't mistake these for a PC connection. Digital cameras often come with video-out terminals, USB connections, and even audio jacks. To avoid confusion, refer to your owner's manual. A quick glance at the annotated diagram of your equipment (whether it's for a flash or camera) will tell you everything you need to know.

By using PC adapters for both the flash (1) and camera (2) you can easily connect any piece of equipment you have—no matter how old or what the brand may be. (3) You will need to ensure that the PC cord you purchase (4) has the correct connectors available. If your camera adaptor has a female end (5) then you will need a cord with at least one male end (6). When all of the cords marry up, you're ready to shoot (7).

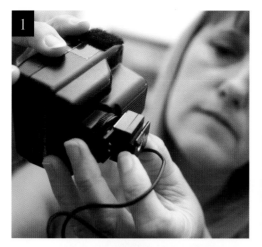

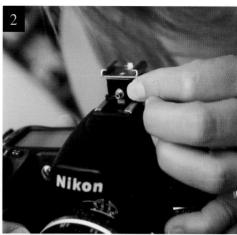

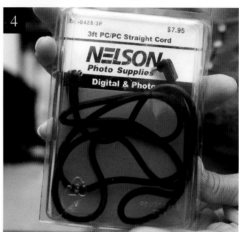

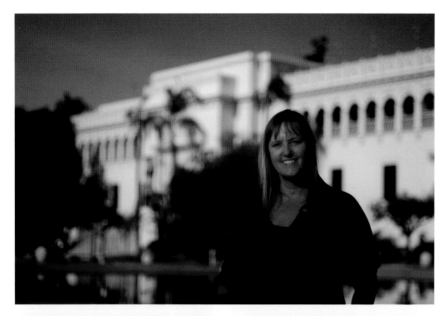

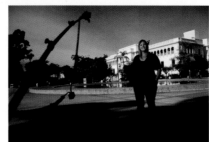

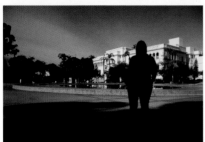

To blur the background in the top image, a larger aperture (f/1.4) was chosen. This forced the use of a faster shutter speed ($\frac{1}{5000}$ second) and an off-camera, external flash set to high-speed sync. Without the flash, the subject would have been too dark—as shown in the middle left image. If the photographer had dialed in a slower shutter speed to illuminate his subject well, he would have lost his background, as shown in the bottom left image. A hand-held, ten-foot light stick was used (page 99) and the flash was connected with two six-foot dedicated TTL flash-sync cords. This is shown in the middle right image. The bottom right image shows what the background would have looked like with a smaller aperture (f/5) and slower (within sync speed) shutter speed ($\frac{1}{250}$ second).

Depending on the equipment you own, you may find that you do not have a PC terminal. Sadly, many cameras and flashes today do not offer this option. If you find yourself in this group, no worries; there are plenty of adapters available. While local camera stores may shy away from selling these classic connection tools, the internet provides a plethora of inexpensive options.

Getting connected is easy; it simply requires a cord. You'll find many PC cords to choose from at camera stores and on the internet—all with varying lengths and connection types. For hand-held work, we suggest a coiled five-foot cord. This will keep your camera bag organized and uncluttered. Straight cords (while less expensive) tend to become tangled with other gear. The five-foot length is of major importance. Shorter cords don't allow

for the type of creative maneuvering (feathering and tiering) you'll want to do. Don't short change yourself; buy a long, coiled cord.

When purchasing a cord, make sure it matches the PC terminals on your camera and flash. For instance, if the connections on your camera and flash are both female, you'll need a cord that has two male ends. If your camera or flash lacks the appropriate PC terminal and you were forced to purchase an adapter, make sure that the cord you buy will connect to this properly.

A TTL Connection. Our favorite way to make a wired connection is with a dedicated TTL sync cord that attaches from the hot shoe of the camera to the foot of the flash. This is the most reliable connection and keeps any advanced fast-sync speed options in play.

Our favorite way to make a wired connection is with a dedicated TTL sync cord . . .

Ultimately, a wired or corded connection between the camera and flash gives the artist a wealth of options that just weren't available when his tools were "stuck" to each other. The freedom of independent action between the camera, the flash, and the artist will open the door to creative possibilities that few realize.

Skip the Flash Bracket

You'll be tempted to purchase a flash-bracket system, a support base from which you can control the camera and flash together, having them work as one solid unit. On the surface, this sounds like a great idea . . . but it's actually riddled with problems. The magic of off-camera flash happens when the flash is actually *off-camera*—pointed in a direction that is impossible when stuck to the camera. When your flash is mounted to a bracketing device, it is still locked into place, giving you essentially the same options as when the flash was placed directly on the camera's hot shoe. Free your mind and your options—go off-camera with your flash, *way* off-camera!

Using a flash bracket is still considered an on-camera flash approach. The photographer will still be locked into thinking about his foremost tiers of graphic information above all else—missing out on a wealth of other more daring options.

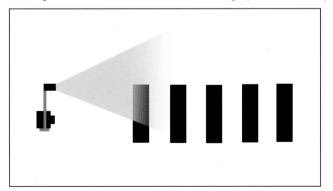

Even when bouncing, the photographer will still be corralled into thinking only about his foreground set of graphic tiers—missing out on a wealth of other more daring options.

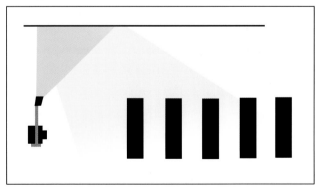

It will take some time to get used to using a corded flash. It's not only physically different, it also requires a different way of thinking—but don't make it any more complicated than it really is. This isn't rocket science, after all. Take a look at your images; if you don't like what you created, change something. Do you need more power? Do you need modification? A faster shutter speed? A narrower beam of light? Think about what you're doing and embrace the learning process.

Changing the Angle of the Flash

When the flash was attached to the camera, you could only light foreground elements from one angle—or, at the most, bounce the light from a nearby source, spreading the wealth amongst those elements closest to you. While nice, this approach is limiting.

With the flash off-camera and hand-held, you can now vary the direction of the light you're producing, filling in shadows or creating new ones. By simply twisting your wrist and pointing the flash in a different direction, you change the very heart of your message. You can decide to play with the power of natural light, going with the grain, or you can be a maverick and push your flash against the natural light to create a unique sense of drama.

Your arm, hand, and wrist will become an extension of your thought process. You'll feel like you're pushing light, directing it to specific locations; wherever you can point your arm, you can add light. That kind of control is a powerful feeling for an artist. You've now got a paint brush that can change reality—and it's shooting right out of your arm!

Feathering the Flash. Here's a simple experiment: instead of aiming your flash directly at your subject, try pointing it slightly to the right or to left of it. Allow some—but not all—of the light to hit your target. What you'll find is that the edges of your flash are soft and offer some of the most pleasing light your flash can produce. It's very similar to the softness provided by the pop-up flash scatterbox (see page 37). Using this soft edge of your light is called "feathering" the flash. It's a technique that you'll want to become very familiar with.

With the flash off-camera and hand-held, you can now vary the direction of the light you're producing . . .

Tiering Your Flash

To grow as an artist, you have to move beyond your subject-only bias. Think about what could happen if you were to concentrate on something other than the thing directly in front of you. Skipping tiers of graphic information with your flash improves your vision. It forces you to look for the unusual and to create messages that no one else can. With an off-camera flash you can now direct your light at a graphic tier other than the one closest to you.

This is groundbreaking and marks a pivotal moment in the life of an artist with a camera; no longer are you limited to thinking about subjects only. Now your background (or foreground) can be equally important— and lit to show it. You can stretch out your arm and move the flash around, wrapping that light around the front tiers and pointing it at something different. You'll be amazed at what you can accomplish when you put your mind (and your forearm) to work.

If you're new to the idea of tiering your flash, you'll need to practice. It's a different way of thinking and goes against how most people approach taking a photograph. You'll need to "give up" your subject a bit and concentrate instead on colors, tones, and meaning. Aim your flash at the things you've never noticed before—like your background. Open your eyes to something different and open your heart to true meaning. If you're

Once the flash is off-camera the need for constant modification decreases. Since the flash is no longer coming straight from the flash, the glare it produces can be dealt with through the expert use of a polarizer.

When you stop pointing your flash directly at your subject, three amazing things happen. First, you will never be bothered by red-eye again. Second, the light the flash creates will be scattered, resulting in very little glare. Third, you'll be free to light multiple graphic tiers with just one flash. By aiming between the graphic elements, your flash can be made to illuminate each with its feathered edges, striking them with some of the softest light you have ever seen. In the top left image we see what happens when the flash is fired directly at the subject. In the top right image, the flash has been feathered to the right. In the bottom image, the flash was pointed between the model and the advertisement. It was allowed to bathe both the model and the wall in light. Again, this type of approach is impossible if the flash is stuck on top of the camera.

This image would have been impossible with a camera-mounted flash. Instead, the photographer wrapped his flash around the first tier of graphic information and shined his light on the second. By simply hand-holding the flash and "skipping" tiers of graphic information, you take your flash and your message to the next level. You are no longer just a photographer with a flash, you're an artist with a mission.

honest in your pursuit, then the beauty of what's around you will find you—this we promise.

Modification Options

While a correctly turned polarizer will eliminate all glare from your flash when positioned perfectly, there will be plenty of times when that just isn't possible. It's then that you can call upon all of the modification options

Keep Your Eyes Open

Look beyond what's in front of you and make a decision as to how each tier of graphic information should be lit. Sometimes, you can line things up in such a way that you illuminate several graphic tiers at a time with your one flash.

you've learned so far. Since the flash is now off-camera however, you can actually up the ante and use larger and even more creative modification options. Many enthusiasts use shoot-through and reflective umbrellas, reflectors, or bounce cards—as well as more elaborate light-funnel systems—on their off-camera flashes.

Again, though, keep in mind that as your light source grows in size, the apparent output of your flash diminishes. Your classic options remain solid; to regain the lost light, you can use larger apertures, move the flash closer to its target tier of graphic information, or bump the ISO to a higher setting.

Something magical happens when you begin aiming your flash at various tiers of graphic information—things other than your subject. You'll be lighting your intent, not just whatever is in front of you. In the images here, the photographer decided to light the background colors and shapes instead of just the flowers.

ABOVE—For many, the search for artistic expression begins with their first tiered flash. Here, the photographer used an extreme blur to isolate the mood of the scene and the colors of the flower. A low-power off-camera flash was feathered across the plant—and, more importantly, illuminated the background, which was way too dark for the artist's tastes. Without an off-camera flash, the feathering technique, and a vision to guide their implementation, this image would not have been possible. MIDDLE ROW, LEFT AND RIGHT—Most photographers concentrate too heavily on taking pictures of "things." Here, the photographer succeeded in taking a well-lit picture of a plant, but there is no real expression going on. BOTTOM—Once you've made up your mind to express yourself and have chosen an aperture that will allow the perfect amount of blur in your image, then the power settings, flash distance, angle of coverage, and more will make themselves known.

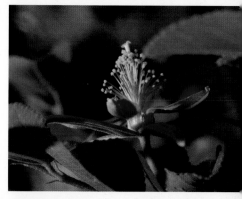

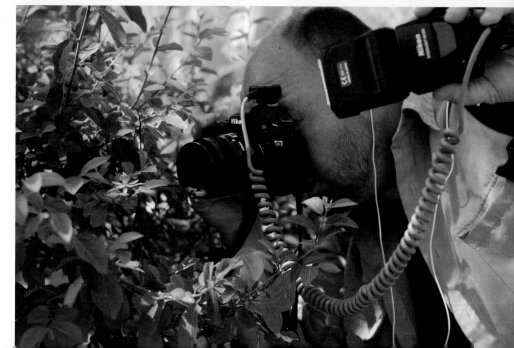

Key Points for Chapter Four

Off camera flash brings with it five new message-building options and two distinct consequences.

OFF-CAMERA OPTIONS

1. Changing the angle of the flash.

2. Feathering the flash.

3. Using the polarizer.

4. Tiering your flash.

5. Using even larger modification equipment.

OFF-CAMERA ISSUES

1. Supporting the flash.

2. Communication between the camera and flash.

A snoot made out of a potato chip canister is seen here zeroing in on a sand-brushed boulder. Snoots are effective modification tools for off-camera flash photography, allowing you to point the hand-held flash at something very small and add just the right amount of light.

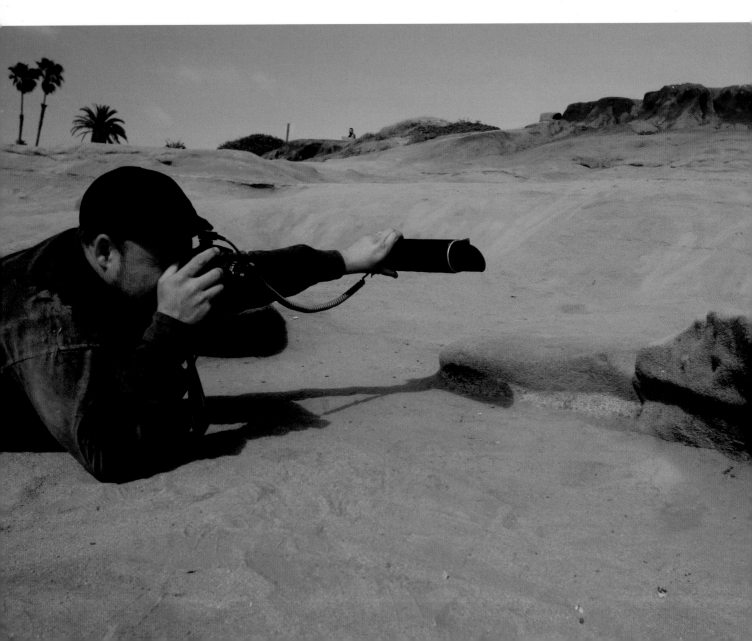

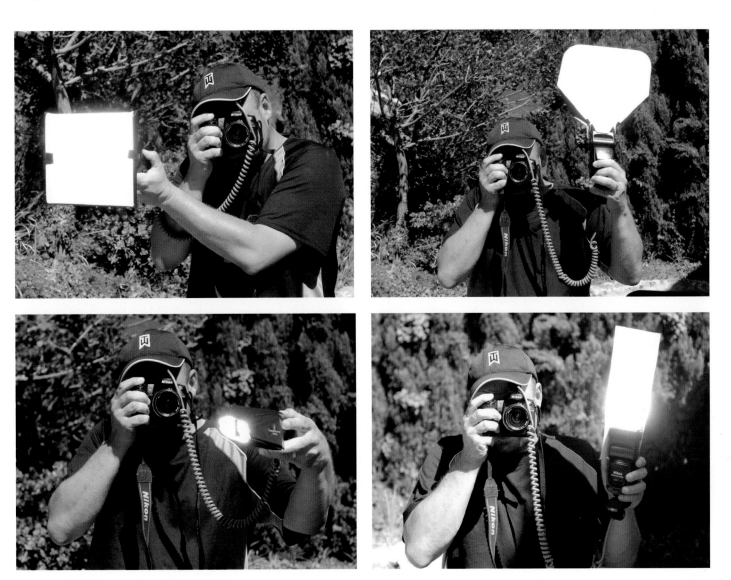

Even when used off-camera, basic modification tools still hold their effectiveness. Shown here are three LumiQuest products: the SoftBox III (top left); the Big Bounce (top right); and a Snoot (bottom left). The bottom right image illustrates the effectiveness of a simple cut-out piece of cardboard, which is then attached to the flash with a rubber band.

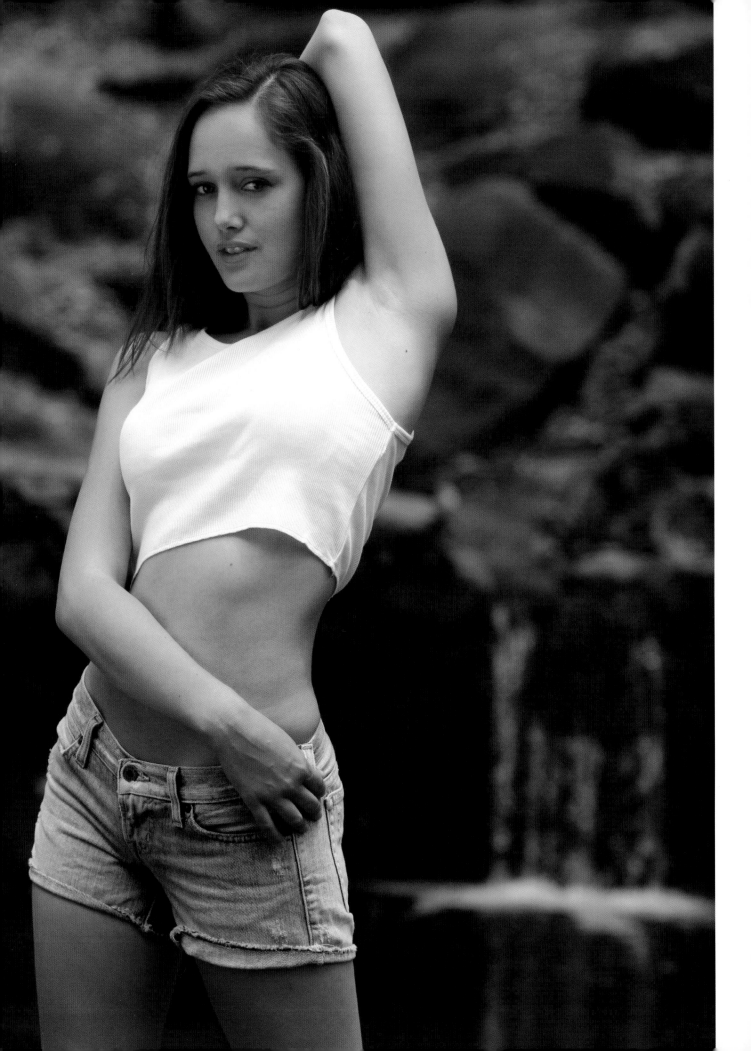

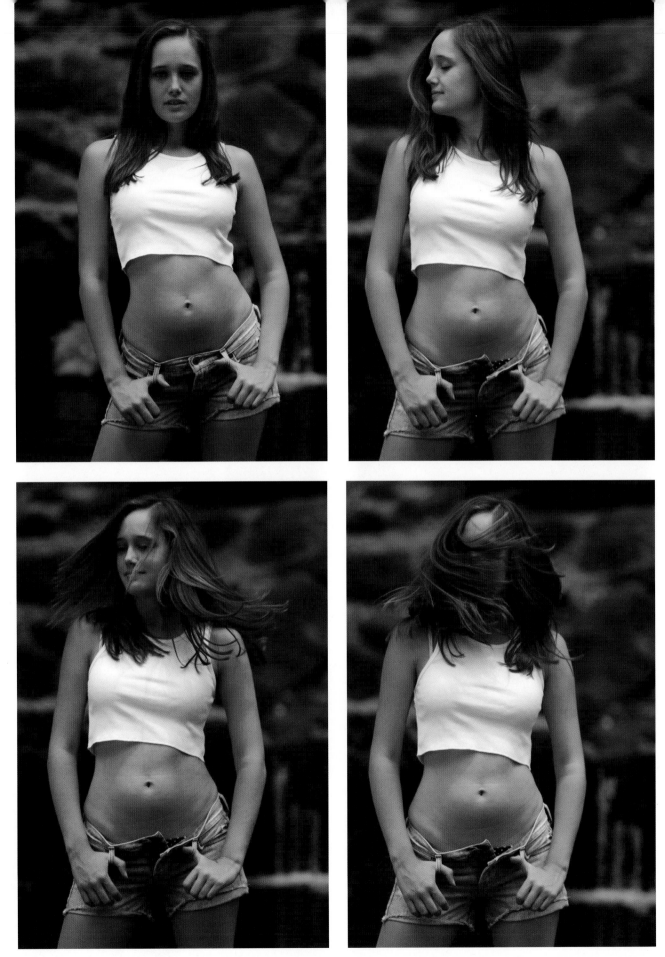

FACING PAGE—A large LumiQuest softbox diffused the light to such a point that it's nearly impossible to tell light was added with a flash. ABOVE—When using a larger aperture, the apparent flash power grows. This enables you to choose a lower flash setting—which, in turn, allows for a quicker recycle time of the flash—allowing it to keep up with a fast motor drive.

LEFT—For the in-camera black & white artist, off-camera flash shines like no other option can. When a knowledgeable photographer applies his camera's internal filters (and other in-camera options, such as white balance, contrast, and sharpness) along with a colored flash (in this case red), amazing things can happen. BELOW—In the left image, a red-filtered flash was positioned to hit the back tiers of graphic information. In the right photo, the flash was fired at full power at the flowers in the front. A high contrast setting, low white balance, low ISO, high sharpening, and red internal filter setting were all applied in-camera, as well. This is what gave these images their powerful contrast and amazing detail.

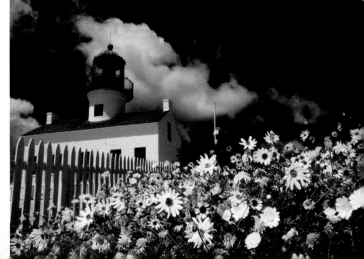

5. The Wireless Approach

It takes guts to use a flash off-camera and requires skill to make it work, but with resolve comes success. The mastery of wireless off-camera flash will take you one step closer to your true goal of artistic freedom.

The challenges of flash photography are great, but the rewards are well worth the price. If you've followed along in the book, you've pushed yourself far, building skills, gaining experience, and finding pride. Now comes the end gambit: do you have what it takes to put all of that to the test? Do you have the mettle to take your flash and message-building skills to the limit? Do you really have what it takes to create art with your camera and to take your flash far from the camera?

Communication Through the Air

There are only two ways of triggering your flash wirelessly: optically (using another light source as a triggering device) or through the use of a radio transmitter and receiver.

Radio Triggering. The radio option is, by far, the best; it's cheaper, easier to use, and more reliable. To trigger your remote flash, we recommend a simple Cactus radio transmitter and receiver combination. At less than $40

We recommend using the Cactus radio transmitter and receiver. At $40 a pair, it's an extremely inexpensive communication option.

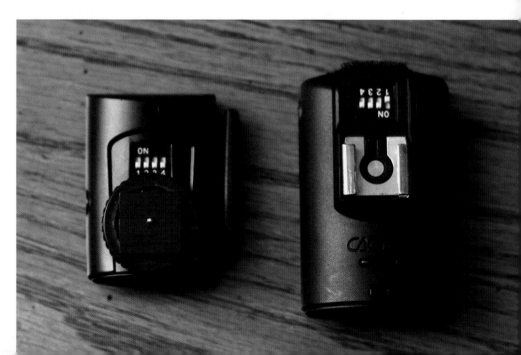

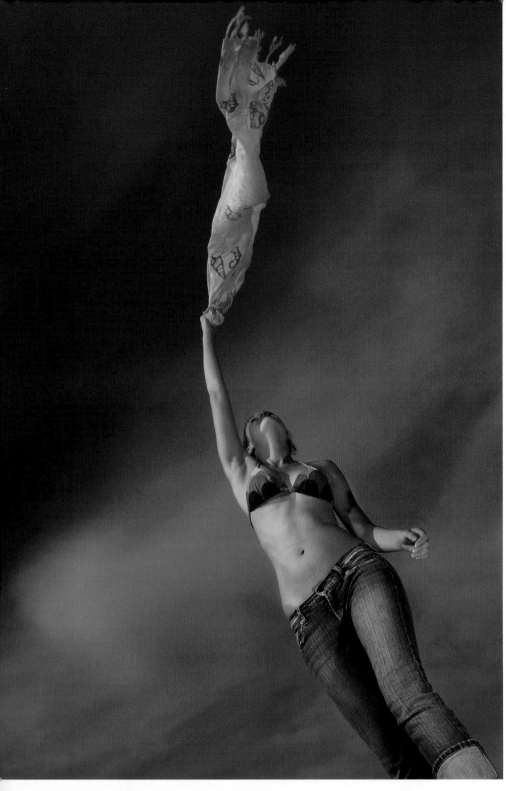

Off-camera wireless flash offers the optimum in control. With your flash now positioned well away from the camera, there is no excuse for an image not to appear as you like it. For these images, a volunteer (thanks Ed) held a flash and pointed it at our subject while each student in the workshop created their own version of the scene—changing the white balance, contrast, saturation, and focus to match their own unique vision.

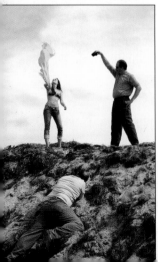

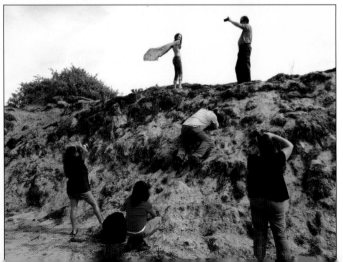

a pair, there really is no better option for the manual off-camera flash photographer. Attach the transmitter to your camera and the receiver to your flash (any flash) and you're ready to shoot. As a manual shooter, there will be no need to worry about camera or flash settings; you will have already dialed those in.

Beyond this, all of the same rules, processes, and techniques apply as before—except that you do lose the high-speed sync option. This isn't that big of a deal, since you already know how to employ the cross-polarizing technique or to use several neutral-density filters to eliminate excess light.

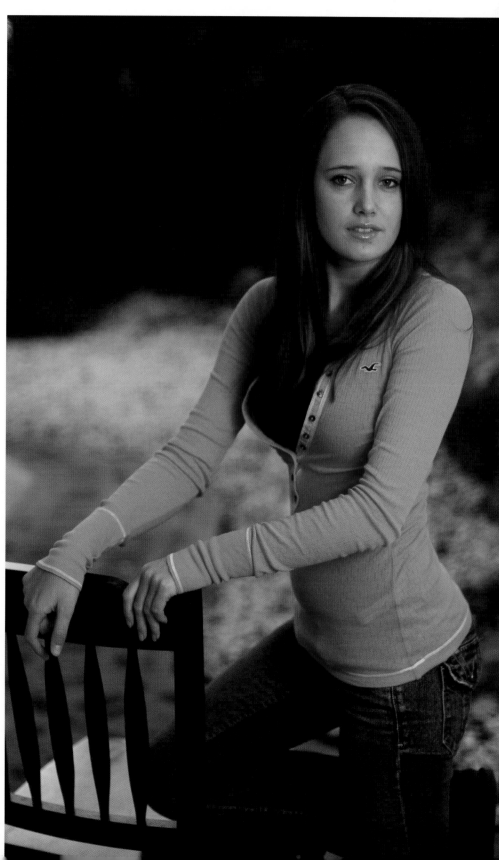

When the flash is set to gently illuminate your subject, it should just caress, not overwhelm. In the image directly below, we see a perfectly illuminated model. In the bottom photo, we see what happens when the flash is set too high.

There are, of course, other radio systems available. Pocket Wizard is a very popular brand among photographers looking for a way around manual shooting. They offer a transceiver that allows for both manual and automatic shooting . . . but at nearly $200 a unit, this is a very expensive way of getting your flash to behave. As we tell our students, it really pays to be a confident manual shooter.

Optical Triggering. You also have an optical choice when it comes to triggering your off-camera flashes. This comes in the form of small optical triggering devices that sit on the foot of your flash. When they sense another flash firing they send a small electrical signal to the flash they are attached to and force it to fire. This is called a "slaved" flash. The flash creating the triggering burst is the "master" unit.

This is a classic approach, but it has some drawbacks. First, it requires a line-of-sight triggering scenario. If the receiver can't see the triggering flash, it will not fire its own unit. This prohibits certain placement constructs that you, as the artist, may feel are important—such as backlighting and complex side-lighting scenarios. Additionally, while slaved flashes are extraordinarily useful indoors, they don't work so well outside. If there is an excess of ambient light (such as sunlight) there is a strong chance the receiver will not "see" the triggering flash. Plus, the price can be prohibitive. A good optical device will cost $50 or more . . . and if you're going to spend that much on a tool that has limitations, why not spend *less* on a radio version that doesn't?

Many camera manufacturers today offer an advanced lighting system that employs a similar optical slave/master technology. This is limited, as well, by line-of-sight prerequisites and requires expensive proprietary flash

BELOW AND FACING PAGE—To maintain the beauty of the sky above San Diego's skyline, a single hand-held flash was employed. This extra light, aimed at our model and her concrete perch, enabled the photographer to choose a shutter speed that allowed the background to look the way it does. Any shutter speed slower than this would have created a background that was just too bright for the intended message.

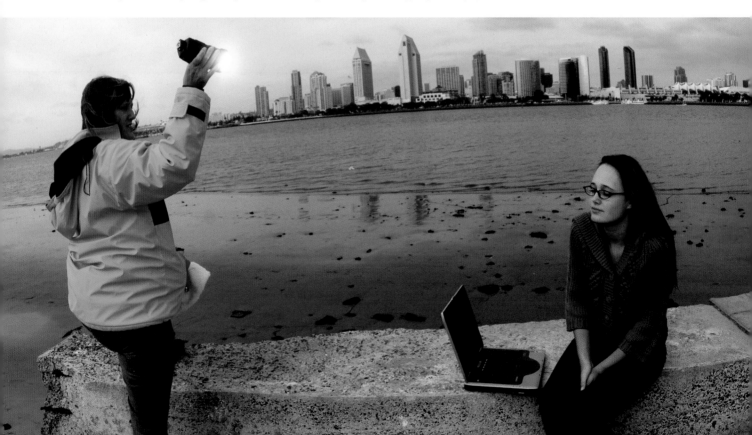

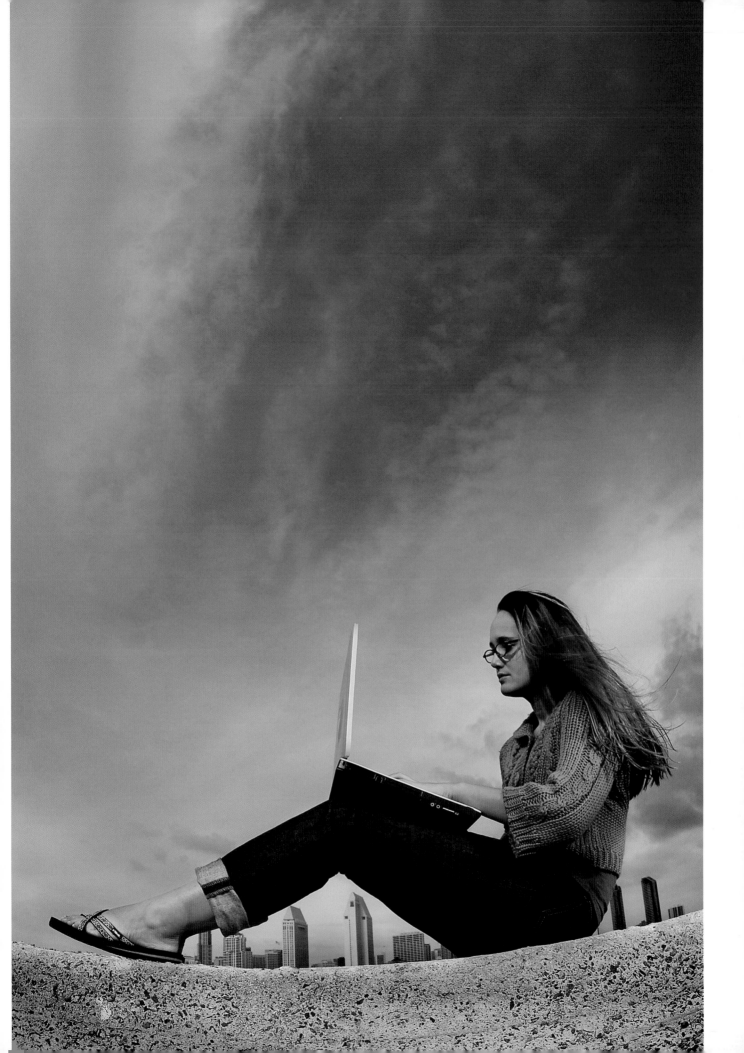

units to work. Again, a simple radio transmitter and receiver will outperform this advanced system—and will do it for a fraction of the cost. There is nothing advanced about a flash system that limits you to a line-of-sight firing scenario.

Support

Once the flash is completely away from the camera, you will need a way to support it. Light stands are a classic option and provide a stable foundation. There are many to choose from. Our preferred light stands are usually lightweight, collapsible, and easy to pack. When using a light stand, you stand the very real chance of it toppling over, so a few small sandbags (available at most camera stores) are highly recommended.

Light stands are a classic option and provide a stable foundation.

One of our favorite support tools is a long ten-foot "light stick." This is simply a lightweight light stand with its legs broken off.

Modification

With wireless control, the flash modification options grow yet again. Since the flash can now be attached to a light stand, so can its modifier. Companies such as Lastolite and others make extra-larger softboxes, diffusion panels, and light stand–supported flash reflectors that take advantage of this. While requiring a bit more setup time, the light they produce is well worth the effort required to set them up.

A single wirelessly controlled flash shooting through an umbrella is seen here—along with its support: a light stick.

While you can purchase hand-held extension handles, a light stand will usually give you a much greater reach.

Our favorite light stick is made from an inexpensive (less than $30) light stand. Typically, you'll have to break the bottom legs off with a hammer.

You may have to pound out any imperfections on the tail end of your light stick to keep it smooth.

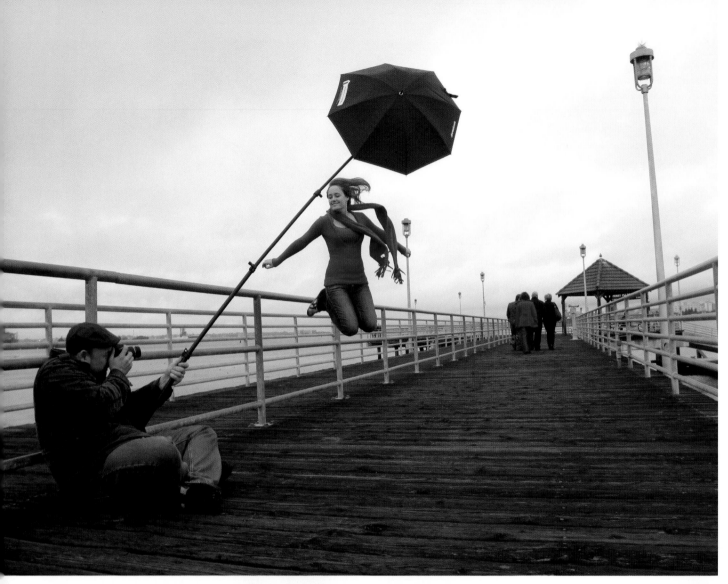

THIS PAGE AND FACING PAGE—A ten-foot light stick, a reflective umbrella, and a simple $40 radio transmitter/receiver set allows for some very creative, on-the-fly photography. The stick is actually quite well-balanced when resting on the photographer's hip and provides for an unbelievable amount of light. RIGHT—The light stick helps to produce a light source that's simply impossible any other way.

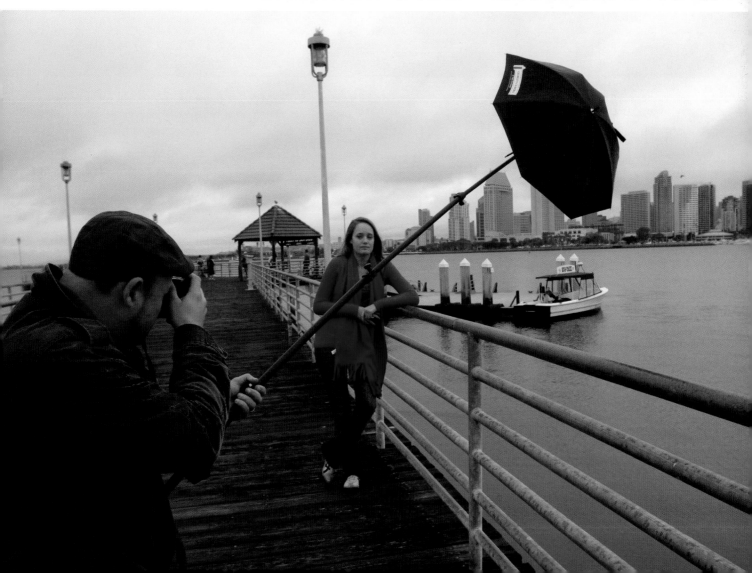

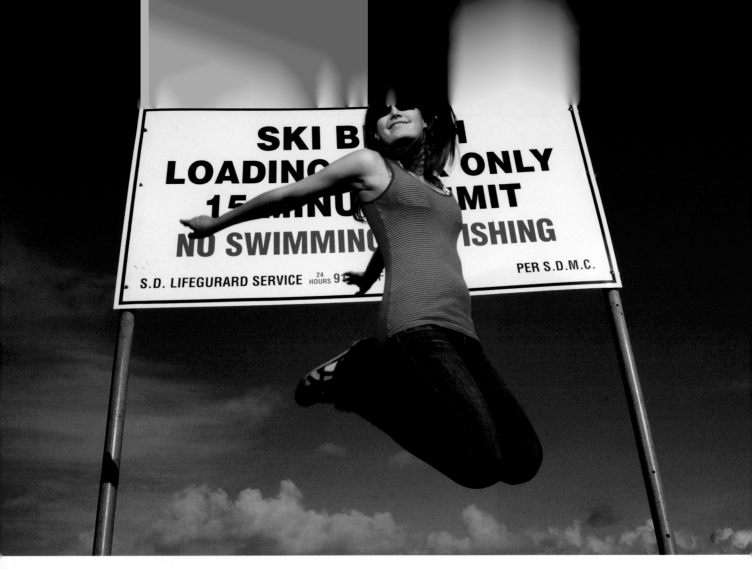

A home-made light stick was employed as a means of raising the wireless flash to a more agreeable angle.

Once the flash goes wireless, your choices of support will grow. In the bottom image, a flash has been mounted on a light stand and fitted with a Lastolite Hot Shoe Ezybox Softbox. This wonderful device enlarges the light dozens of times before it strikes your subject. In the top pair of images, a LumiQuest SoftBox III is attached to a flash mounted on a Lastolite Ezybox Hotshoe Extending Handle.

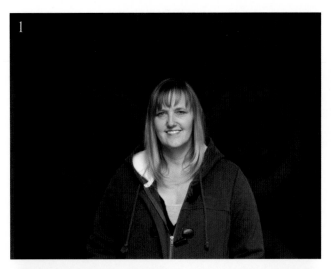

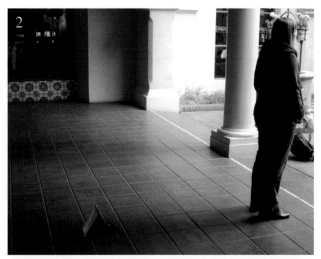

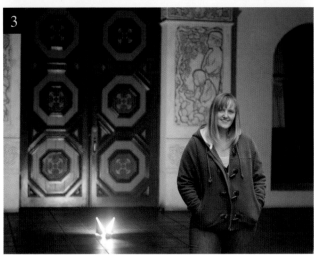

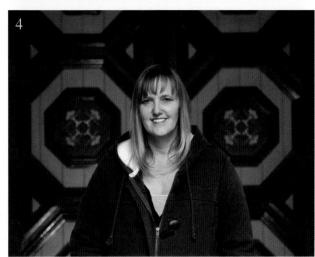

Key Points for Chapter Five

1. If you use optical triggering, you'll have to use a line-of-sight approach. This will limit your artistic choices.

2. If you use a radio transmitter and receiver, be wary of expensive setups. These aren't needed if you're a manual photographer. There are other options.

3. When using either a radio or optical triggering device, you will probably lose your high-speed sync capabilities—remember to use the cross-polarizing or neutral density filter techniques when dealing with excess light.

4. Think outside of the box when dealing with support and modification.

In this scene, the loss of detail on the background is striking (1). To correct this, we can add off-camera flash to illuminate the wall. As seen here (2), the ground sometimes makes the best support system. You can see the flash was aimed at the wall and was enlarged with the help of a large LumiQuest softbox (3). The final image (4), reveals a background with much more pleasing detail.

6. Taking the Next Step

Now that you've got a handle on the control of your flash and how to modify the light it's producing, it's time to start making meaningful mistakes—errr, we mean messages.

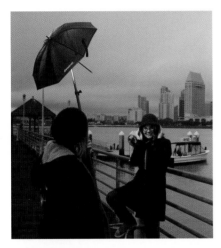

Once you've mastered the basics of adding light, it's time to start playing outside. Grab some gear and a few family members, then head out into the great unknown. Sure, it's scary the first time you do it—and, trust us, you will make loads of mistakes. But from each of these

An extra bit of illumination was added to our model to help isolate her from the background. The flash was modified with a reflective umbrella, set atop a homemade light stick. This was held in place by an assistant and triggered with the use of an inexpensive wireless radio transmitter and receiver. All of this was done while the photographer dialed-in his aperture and shutter speed to best light his message—and after he adjusted his white balance, contrast, saturation, hue, and sharpness in-camera to best bring about the "feeling" he wanted to share. Hey, no one ever said real photography was going to be easy.

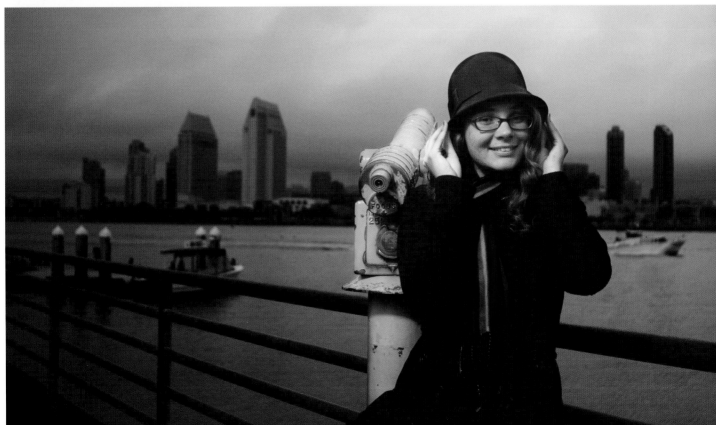

you'll learn something important. Take your time and explore what your monitor offers. The truth and all the answers lay buried there; don't let this opportunity slip away.

Study your images while in the field and try very hard to make all the needed corrections while the situation—your camera settings and all of your mistakes—are fresh in your mind. There is no better teacher than pure experience and you'll get an awful lot of it from doing this.

As you begin, don't expect more than one or two decent photographs from each of your outings. Rest comfortably with the fact that, with practice, everyone gets better—they don't have a choice.

Start simply. Create a darker-than-usual background with your aperture and shutter. Place your flash close to your subject, turn your polarizer to eliminate any excess glare, and fire your flash. Try to get your subject to stand out from the background with just a touch of illumination. If you need to use a light stick or have an assistant hold the flash, then get one. Don't bother with keeping the flash on-camera, you can do that at home. Hit your subject with an off-camera wireless flash and don't look back.

Try to get your subject to stand out from the background with just a touch of illumination.

What you'll quickly discover is that you do have the power to change reality, to *create* instead of just *capture*. Explore the lessons taught in this book and you'll be creating your own dramatic just-one-flash images in no time. Good luck and good shooting!

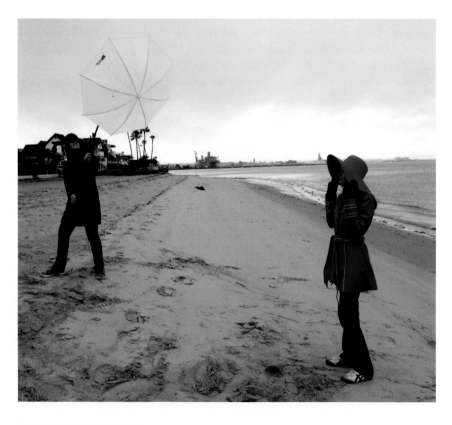

How the world actually appears (left) varies greatly from how it can be forced to appear (facing page). It's the photographer's ultimate responsibility to decide upon the mood of his image. Here, a darker-than-usual background was created using cross-polarization. A "sticked" off-camera flash was modified with a medium-sized shoot-through umbrella. The camera settings were dialed-in based on taste.

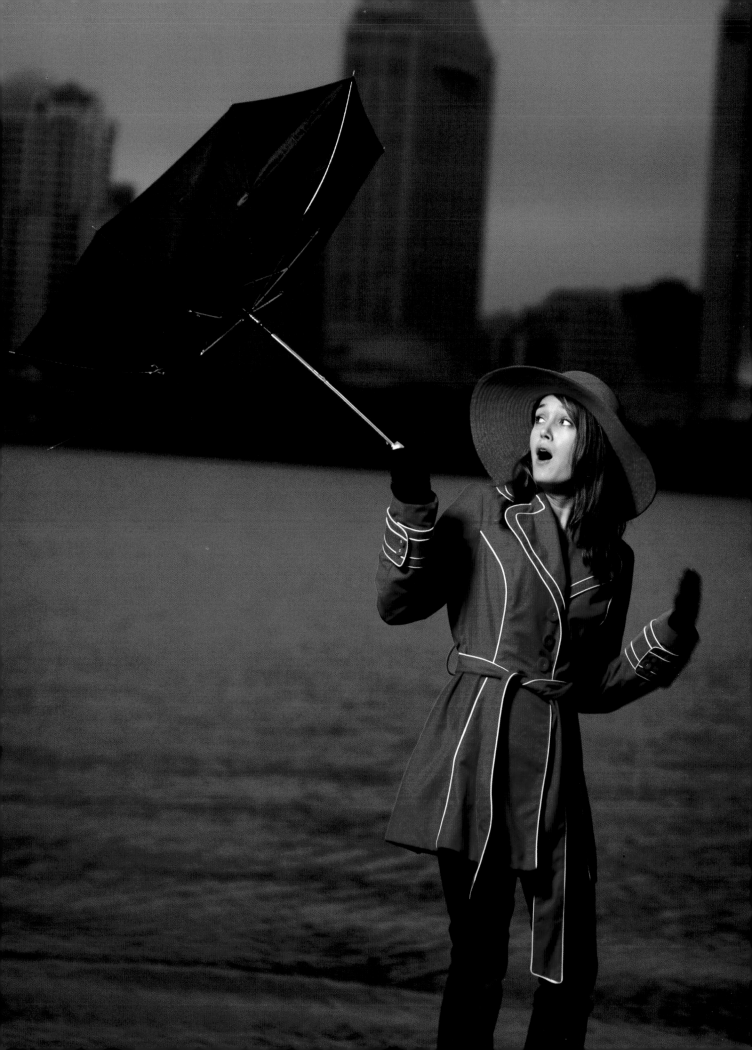

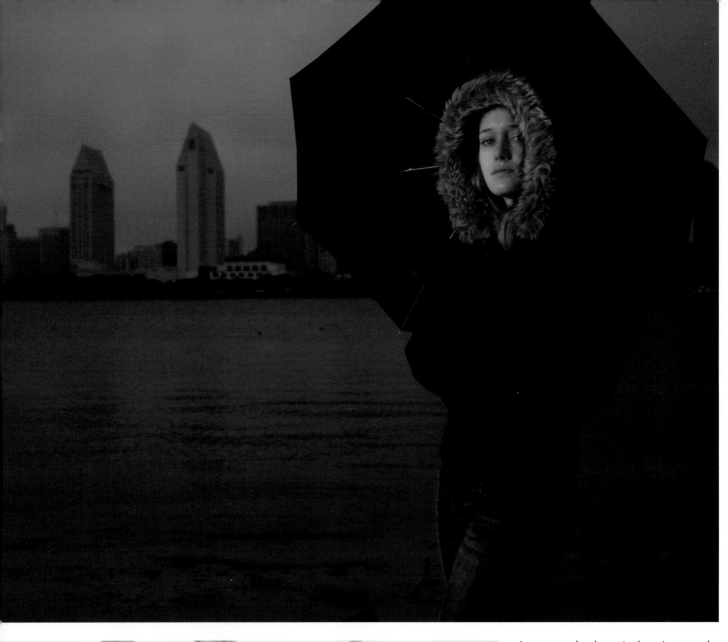

As you can clearly see in these images, the background was changed considerably from how it actually appeared. Decisions about the background—the darkness levels, contrast settings, white balance options, and more—should be made before you even begin thinking about using a flash.

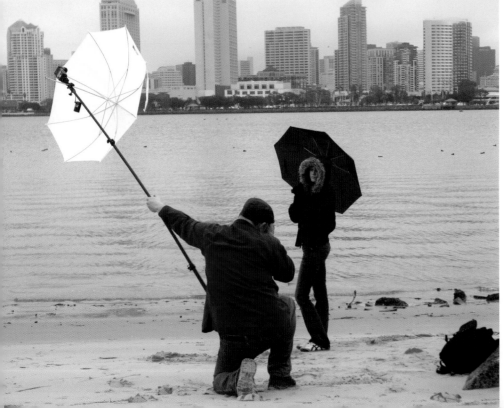

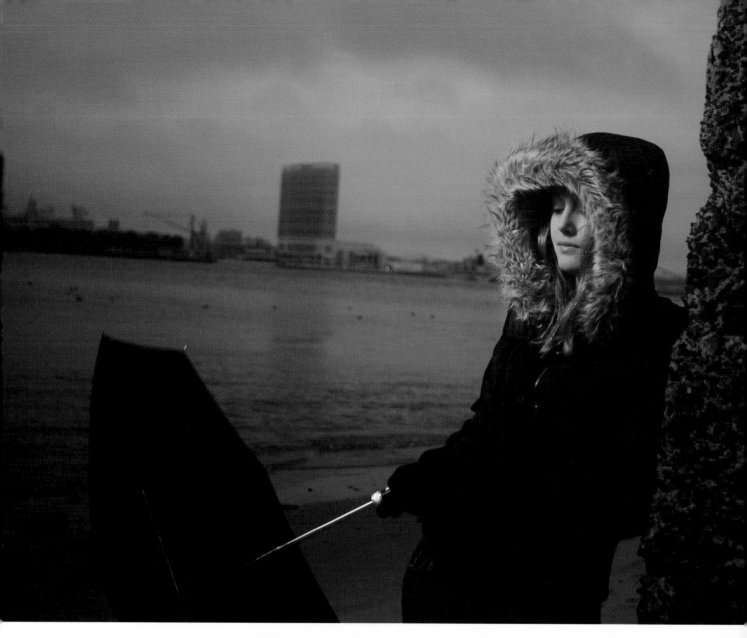

Once your background is lit and "feels" the way you want it to, examine the rest of the graphic tiers and decide whether or not they deserve (or can have) any extra light. If you have at least one flash and the means to effectively deploy it, success will be right around the corner.

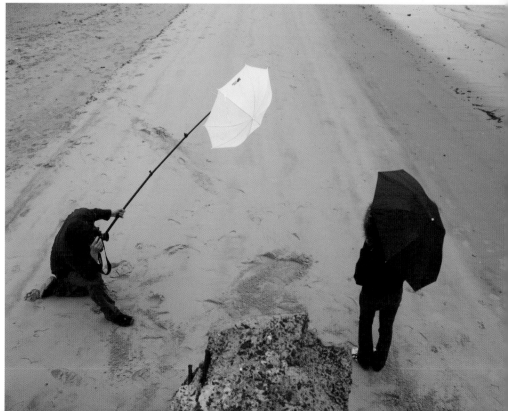

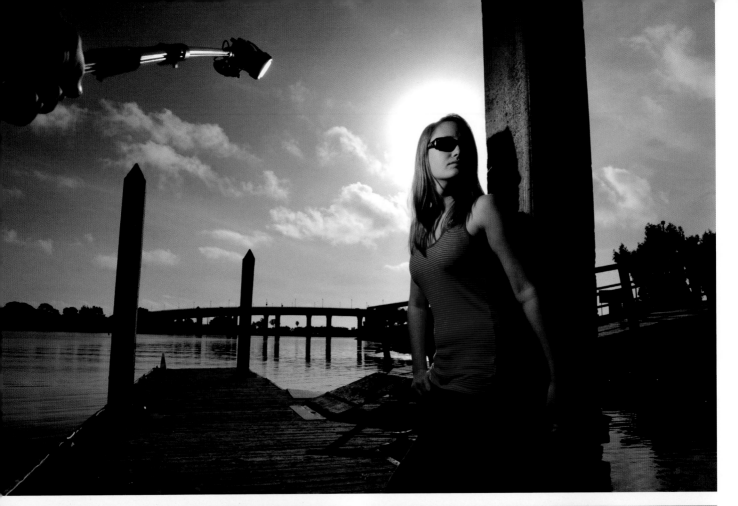

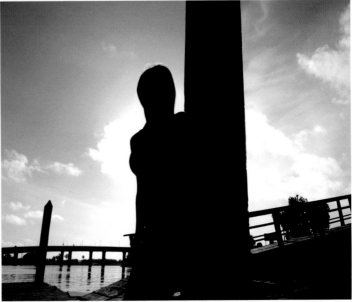

ABOVE—For this series of images, the photographer placed his model directly in front of the blazing afternoon sun. To eliminate the excess light a small aperture (f/11) was chosen. The shutter was locked at $^1/_{200}$ second, since the wireless connection used (Cactus) didn't provide for a fast-speed sync option. In this case, the smaller aperture worked well because the photographer actually wanted more of his background in focus. A flash was then placed on a light stick and positioned very close to the model's head. A heavy contrast setting was applied in-camera, along with a white-balance setting that gave the sky the attitude shown here. FACING PAGE—In the top images you can see how the day actually appeared. The middle photo illustrates the power of the flash—even when pointed directly toward the sun. The bottom two images show the difference that just one flash makes.

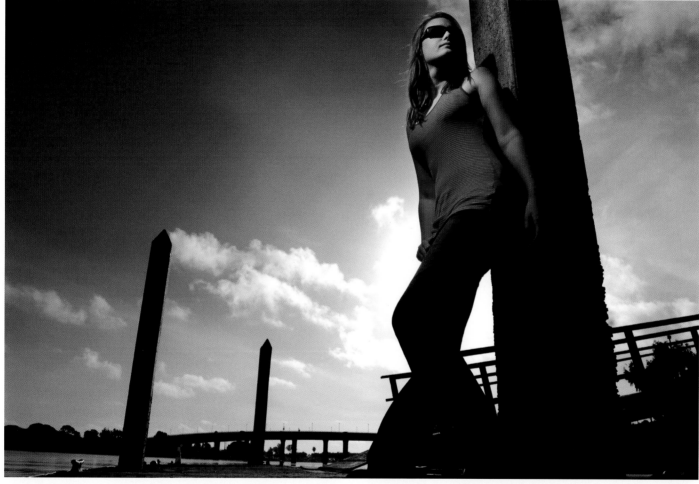
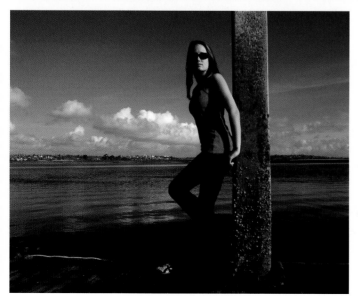
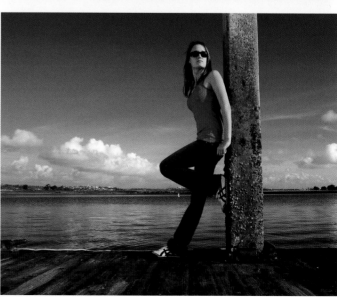

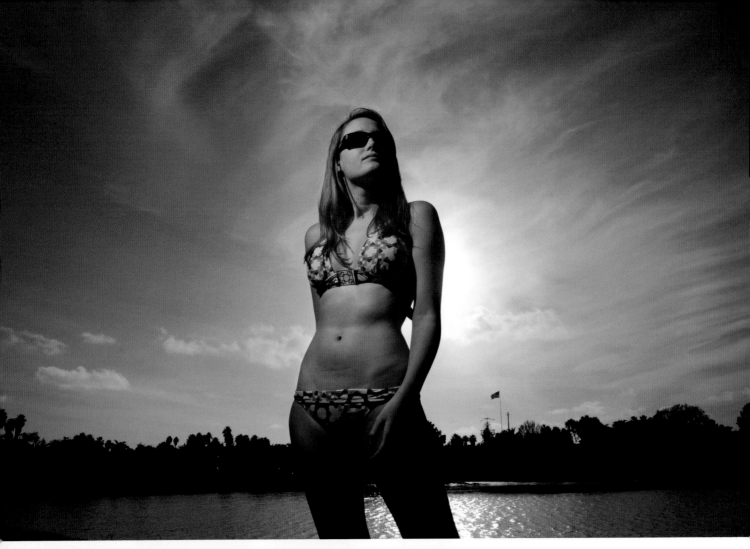

In these images, the model was placed directly in front of the sun again. The goal was to darken the sky, yet bring the model into the light. An aperture of f/14 was chosen to keep both the subject and background in crisp focus—and to darken the background. A wide-angle lens was picked, and the power of the flash was turned to full. The polarizer was used to eliminate any man-made glare.

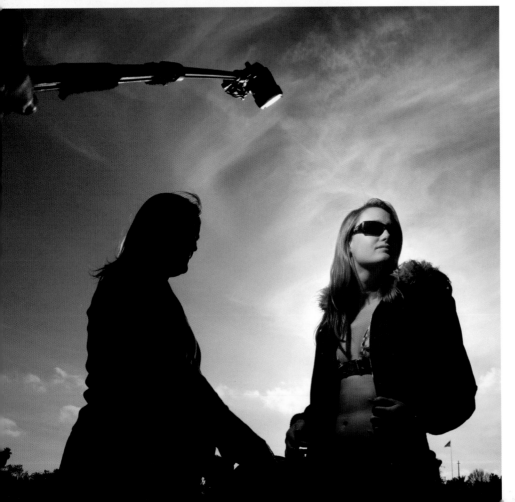

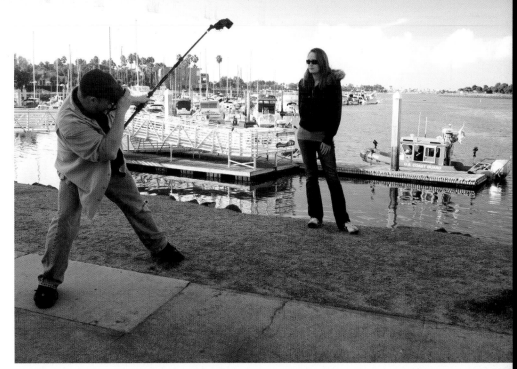

By first choosing an aperture (f/8) and shutter speed ($1/200$ second) that allowed for a darker-than-usual background, the photographer had only to employ a light-stick mounted flash to bring the subject up from the shadows.

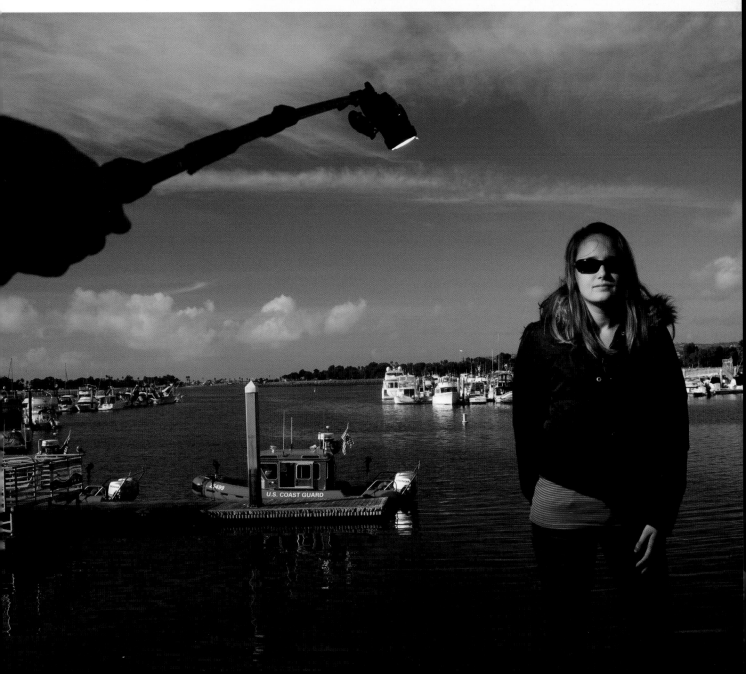

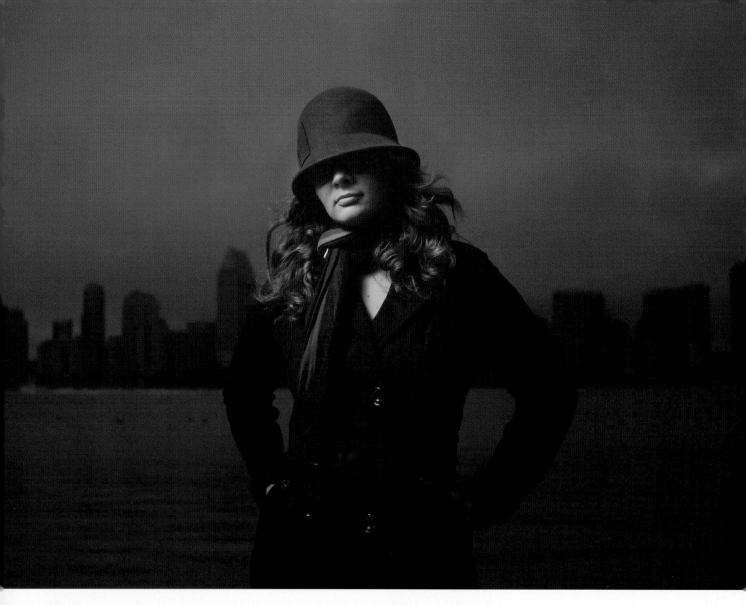

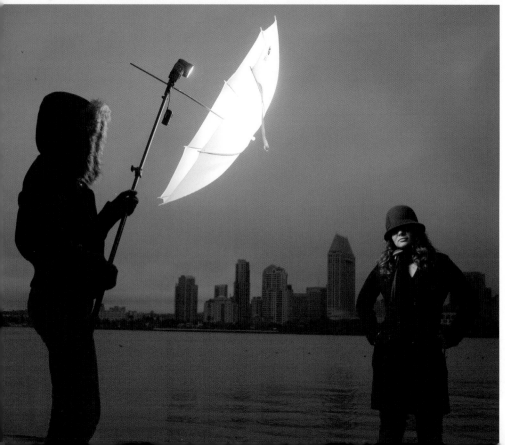

Know what you want to say *before* you say it. This is the best advice we can offer a new photographer searching for artistic freedom with a flash. The background in these images was chosen first, then a flash was employed to bring our models out of the darkness.

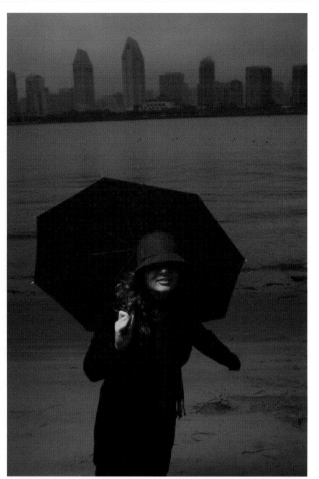

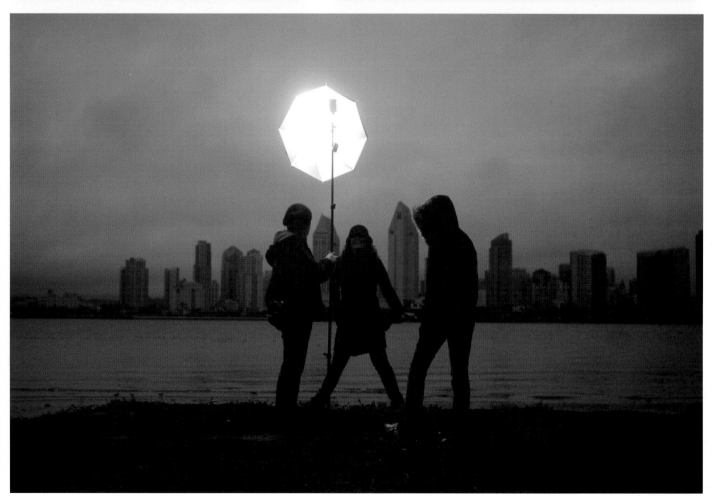

Gear Inventory

Every photographer has his favorite modification, support, and communication tools for flash photography. Here are some of the accessories we used in this book and found helpful.

Pocket Bouncer (LQ-101)

The Pocket Bouncer enlarges and redirects light at a 90 degree angle from the flash to soften its quality and distribute it over a wider area. While no exposure compensation is necessary with automatic flashes, operating distances are somewhat reduced. (www.lumiquest.com)

Quik Bounce (LQ-122)

This unique design offers doors that can be opened to allow 80 percent ceiling bounce while allowing 20 percent of the light to bounce off the remaining surface area, providing fill light and more even illumination. When the doors remain closed, 100 percent of the light bounces off this surface area. (www.lumiquest.com)

ProMax System (LQ-105)

The ProMax System allows 80 percent of the light to bounce off the ceiling while 20 percent is redirected forward as fill light. The system includes interchangeable white, gold, and silver inserts as well as a removable frosted diffusion screen. (www.lumiquest.com)

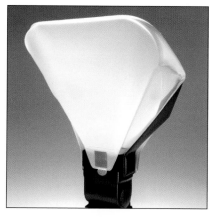

Snoot (LQ-114)

The Snoot isolates the light to a very specific area. Automatic operation may be affected, as the illuminated area is limited. (www.lumiquest.com)

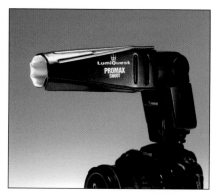

Big Bounce (LQ-104)

The LumiQuest Big Bounce enlarges, redirects, and softens the light. (www.lumiquest.com)

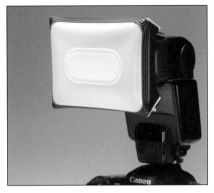

Mini SoftBox (LQ-108)

The Mini SoftBox enlarges and diffuses the light with the flash in the direct flash position. Unobtrusive and low profile, the Mini SoftBox is ideal for press photography and other fast-moving situations. (www.lumiquest.com)

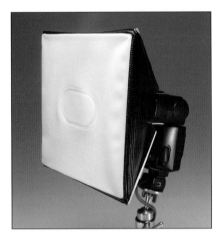

Softbox III (LQ-119)

The SoftBox III is roughly twice the size of the original SoftBox, producing considerably softer shadows. It fits conventional flashes (Nikon, Canon, Sunpak, Vivitar, etc.). (www.lumiquest.com)

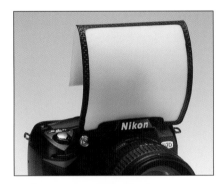

Soft Screen (LQ-051)

The LumiQuest Soft Screen is a diffuser that is designed for the built-in pop-up flash of many digital cameras. (www.lumiquest.com)

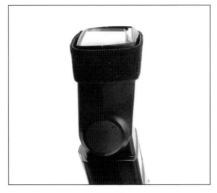

Cinch Strap (LQ-117)

The LumiQuest Cinch Strap enables the photographer to attach LumiQuest accessories without installing a self-adhesive loop to their flash. In addition, wrap-around Velcro attaches LumiQuest accessories for a more secure attachment. (www.lumiquest.com)

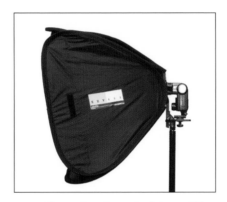

Hot Shoe EzyBox Softbox Kit

The Lastolite Ezybox Softbox offers photographers a portable large softbox option. This softbox creates a large, diffused light source for photographers while in the field. (www.lastolite.com)

Long EzyBox Hotshoe Extending Handle (LL LS2413)

Hand-held, this boom allows for the addition of flashes both at the top of the handle and along its neck. Lastolite offers a variety of softboxes that attach, as well. (www.lastolite.com)

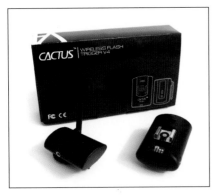

Cactus Wireless Flash Trigger Set V4

With the Cactus Wireless Flash Trigger System V4, you can place multiple flashes at various angles and distances from your subject. Each receiver works with one flash. You can use as many receivers as you wish, all receiving their signal from one transmitter. (www.harvest-one.com/cactusfront/html)

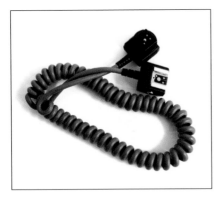

Dedicated (TTL) Flash Cords

Connects the off-camera flash to the hot shoe of the camera, allowing exposure and distance data to travel between gear. The flash fires as the shutter is pressed. These are available online and at most camera stores.

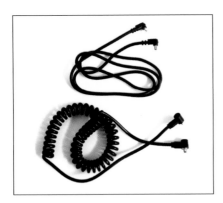

Sync Cords

Connects between the flash and the camera, allowing the camera to "talk" to the flash for firing. These are available online and at most camera stores.

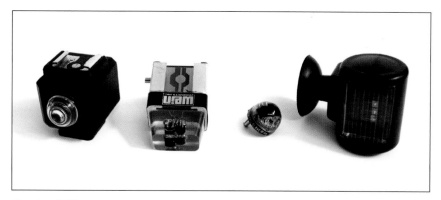

Optical Slaves

Allows the off-camera flash to fire when triggered by a burst of light from the main flash as the shutter is pressed. Optical slaves must be in line-of-sight of other flashes to work dependably. These are available online and at most camera stores.

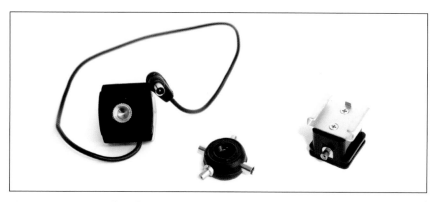

Connectors and Adaptors

Connects various sync cords between flashes for multiple flash work. These are available online and at most camera stores.

Index

Master Lighting Guide
FOR PORTRAIT PHOTOGRAPHERS

Christopher Grey

Master traditional lighting styles and use creative modi-fications that will maximize your results. *$34.95 list, 8.5x11, 128p, 300 color photos, index, order no. 1778.*

THE BEST OF

Family Portrait Photography

Bill Hurter

Acclaimed photographers reveal the secrets behind their most successful family portraits. Packed with award-winning images and helpful techniques. *$39.95 list, 8.5x11, 128p, 150 color photos, index, order no. 1812.*

Professional Marketing & Selling Techniques
FOR DIGITAL WEDDING PHOTOGRAPHERS 2ND ED.

Jeff Hawkins and Kathleen Hawkins

Taking great photos isn't enough! Become a master marketer and salesperson with these techniques. *$34.95 list, 8.5x11, 128p, 150 color photos, index, order no. 1815.*

Professional Portrait Lighting
TECHNIQUES AND IMAGES FROM MASTER PHOTOGRAPHERS

Michelle Perkins

Get a behind-the-scenes look at the lighting techniques employed by the world's top por?trait photographers. *$34.95 list, 8.5x11, 128p, 200 color photos, index, order no. 2000.*

Rangefinder's Professional Photography

edited by Bill Hurter

Bill Hurter shares over one hundred image "recipes," showing you how to shoot, pose, light, and edit fabulous images. $34.95 list, 8.5x11, 128p, 150 color photos, index, order no. 1828.

Professional Filter Techniques
FOR DIGITAL PHOTOGRAPHERS

Stan Sholik

Select the best filter options for your photographic style and discover how their use will affect your images. *$34.95 list, 8.5x11, 128p, 150 color images, index, order no. 1831.*

MASTER'S GUIDE TO

Wedding Photography

Marcus Bell

Learn to capture the unique energy and mood of each wedding and build a lifelong client relationship. *$34.95 list, 8.5x11, 128p, 200 color photos, index, order no. 1832.*

Master Lighting Guide
FOR COMMERCIAL PHOTOGRAPHERS

Robert Morrissey

Use the tools and techniques pros rely on to land corporate clients. Includes diagrams, images, and techniques for a failsafe approach for shots that sell. *$34.95 list, 8.5x11, 128p, 110 color photos, 125 diagrams, index, order no. 1833.*

Digital Capture and Workflow
FOR PROFESSIONAL PHOTOGRAPHERS

Tom Lee

Cut your image-processing time by fine-tuning your workflow. Includes tips for working with Photoshop and Adobe Bridge, plus framing, matting, and more. *$34.95 list, 8.5x11, 128p, 150 color images, index, order no. 1835.*

Softbox Lighting Techniques
FOR PROFESSIONAL PHOTOGRAPHERS

Stephen A. Dantzig

Learn to use one of photography's most popular lighting devices to produce soft and flawless effects for portraits, product shots, and more. *$34.95 list, 8.5x11, 128p, 260 color images, index, order no. 1839.*

JEFF SMITH'S

Lighting for Outdoor and Location Portrait Photography

Learn how to use light throughout the day—indoors and out—and make location portraits a highly profitable venture for your studio. *$34.95 list, 8.5x11, 128p, 170 color images, index, order no. 1841.*

Professional Children's Portrait Photography

Lou Jacobs Jr.

Fifteen top photographers reveal their most successful techniques—from working with uncooperative kids, to lighting, to marketing your studio. *$34.95 list, 8.5x11, 128p, 200 color photos, index, order no. 2001.*

Children's Portrait Photography
A PHOTOJOURNALISTIC APPROACH

Kevin Newsome

Learn how to capture spirited images that reflect your young subject's unique personality and developmental stage. *$34.95 list, 8.5x11, 128p, 150 color images, index, order no. 1843.*

Professional Portrait Posing
TECHNIQUES AND IMAGES FROM MASTER PHOTOGRAPHERS

Michelle Perkins

Learn how master photographers pose subjects to create unforgettable images. *$34.95 list, 8.5x11, 128p, 175 color images, index, order no. 2002.*

MONTE ZUCKER'S
Portrait Photography Handbook

Acclaimed portrait photographer Monte Zucker takes you behind the scenes and shows you how to create a "Monte Portrait." Covers techniques for both studio and location shoots. *$34.95 list, 8.5x11, 128p, 200 color photos, index, order no. 1846.*

Lighting and Posing Techniques for Photographing Women

Norman Phillips

Make every female client look her very best. This book features tips from top pros and diagrams that will facilitate learning. *$34.95 list, 8.5x11, 128p, 200 color images, index, order no. 1848.*

The Best of Photographic Lighting, 2nd Ed.

Bill Hurter

Top pros reveal the secrets behind their studio, location, and outdoor lighting. Packed with practical tips. *$34.95 list, 8.5x11, 128p, 200 color photos, index, order no. 1849.*

JEFF SMITH'S
Posing Techniques for Location Portrait Photography

Use architectural and natural elements to support the pose, maximize the flow of the session, and create refined, artful poses for individual subjects and groups—indoors or out. *$34.95 list, 8.5x11, 128p, 150 color photos, index, order no. 1851.*

Master Lighting Guide

FOR WEDDING PHOTOGRAPHERS

Bill Hurter

Capture perfect lighting quickly and easily at the ceremony and reception. Includes tips from the pros for lighting individuals, couples, and groups. *$34.95 list, 8.5x11, 128p, 200 color photos, index, order no. 1852.*

Existing Light

TECHNIQUES FOR WEDDING AND PORTRAIT PHOTOGRAPHY

Bill Hurter

Learn to work with window light, make the most of outdoor light, and use fluorescent and incandescent light to best effect. *$34.95 list, 8.5x11, 128p, 150 color photos, index, order no. 1858.*

THE SANDY PUC' GUIDE TO
Children's Portrait Photography

Learn how Puc' handles every client interaction and session for priceless portraits, the ultimate client experience, and maximum profits. *$34.95 list, 8.5x11, 128p, 180 color images, index, order no. 1859.*

Minimalist Lighting

PROFESSIONAL TECHNIQUES FOR LOCATION PHOTOGRAPHY

Kirk Tuck

Use battery-operated flash units and lightweight accessories to get the top-quality results you want *$34.95 list, 8.5x11, 128p, 175 color images and diagrams, index, order no. 1860.*

FILM & DIGITAL TECHNIQUES FOR
Zone System Photography

Dr. Glenn Rand

A systematic approach to perfect exposure, developing or digitally processing your work, and printing images that suit your creative vision. *$34.95 list, 8.5x11, 128p, 125 b&w and color images, index, order no. 1861.*

Simple Lighting Techniques

FOR PORTRAIT PHOTOGRAPHERS

Bill Hurter

Make complicated lighting setups a thing of the past. In this book, you'll learn how to streamline your lighting for more efficient shoots and more natural-looking portraits. *$34.95 list, 8.5x11, 128p, 175 color images, index, order no. 1864.*

Lighting for Photography

TECHNIQUES FOR STUDIO AND LOCATION SHOOTS

Dr. Glenn Rand

Gain the technical knowledge of natural and artificial light you need to take control of every scene you encounter—and produce incredible photographs. $34.95 list, 8.5x11, 128p, 150 color images/diagrams, index, order no. 1866.

Sculpting with Light

Allison Earnest

Learn how to design the lighting effect that will best flatter your subject. Studio and location lighting setups are covered in detail with an assortment of helpful variations provided for each shot. *$34.95 list, 8.5x11, 128p, 175 color images, diagrams, index, order no. 1867.*

Step-by-Step Wedding Photography

Damon Tucci

Deliver the images that your clients demand with the tips in this essential book. Tucci shows you how to become more creative, more efficient, and more successful. *$34.95 list, 8.5x11, 128p, 175 color images, index, order no. 1868.*

Professional Wedding Photography

Lou Jacobs Jr.

Jacobs explores techniques and images from over a dozen top professional wedding photographers in this revealing book, taking you behind the scenes and into the minds of the masters. $34.95 list, 8.5x11, 128p, 175 color images, index, order no. 2004.

The Art of Children's Portrait Photography

Tamara Lackey

Create images that are focused on emotion, relationships, and storytelling. Lackey shows you how to engage children, conduct fun sessions, and deliver timeless images. *$34.95 list, 8.5x11, 128p, 240 color images, index, order no. 1870.*

50 Lighting Setups for Portrait Photographers

Steven H. Begleiter

Filled with unique portraits and lighting diagrams, plus the "recipe" for creating each look. *$34.95 list, 8.5x11, 128p, 150 color images and diagrams, index, order no. 1872.*

Lighting and Photographing Transparent and Translucent Surfaces

Dr. Glenn Rand

Learn to photograph glass, water, and other tricky surfaces in the studio or on location. *$34.95 list, 8.5x11, 128p, 125 color images, diagrams, index, order no. 1874.*

100 Techniques for Professional Wedding Photographers

Bill Hurter

Top photographers provide tips for becoming a better shooter. *$34.95 list, 8.5x11, 128p, 180 color images and diagrams, index, order no. 1875.*

DOUG BOX'S GUIDE TO

Posing for Portrait Photographers

Based on Doug Box's popular workshops for professional photographers, this visually intensive book allows you to quickly master the skills needed to pose men, women, children, and groups. *$34.95 list, 8.5x11, 128p, 200 color images, index, order no. 1878.*

500 Poses for Photographing Women

Michelle Perkins

Inspiring images, from head-and-shoulders to full-length portraits, and classic to contemporary styles—perfect for when you need a little shot of inspiration to create a new pose. *$34.95 list, 8.5x11, 128p, 500 color images, order no. 1879.*

Minimalist Lighting

PROFESSIONAL TECHNIQUES FOR STUDIO PHOTOGRAPHY

Kirk Tuck

Learn how technological advances have made it easy and inexpensive to set up your own studio. *$34.95 list, 8.5x11, 128p, 190 color images and diagrams, index, order no. 1880.*

Master Posing Guide for Wedding Photographers

Bill Hurter

Learn to create images that make your clients look their very best while still reflecting the spontaneity and joy of the event. *$34.95 list, 8.5x11, 128p, 180 color images and diagrams, index, order no. 1881.*

ELLIE VAYO'S GUIDE TO

Boudoir Photography

Learn how to create flattering, sensual images that women will love as gifts or keepsakes. Covers everything you need to know—from getting clients in the door, to running a succesful session, to making a big sale. *$34.95 list, 8.5x11, 128p, 180 color images, index, order no. 1882.*

MASTER GUIDE FOR

Photographing High School Seniors

Dave, Jean, and J. D. Wacker

Learn how to stay at the top of the ever-changing senior portrait market with these techniques for success. *$34.95 list, 8.5x11, 128p, 270 color images, index, order no. 1883.*

Available Light

PHOTOGRAPHIC TECHNIQUES

FOR USING EXISTING LIGHT SOURCES

Don Marr

Find great light, modify not-so-great light, and harness the beauty of some unusual light sources in this step-by-step book. *$34.95 list, 8.5x11, 128p, 135 color images, index, order no. 1885.*

On-Camera Flash

TECHNIQUES FOR DIGITAL WEDDING AND PORTRAIT PHOTOGRAPHY

Neil van Niekerk

Use on-camera flash to create lighting that flatters your subjects—and doesn't slow you down on location shoots. *$34.95 list, 8.5x11, 128p, 190 color images, index, order no. 1888.*

Commercial Photography Handbook

BUSINESS TECHNIQUES FOR PROFESSIONAL DIGITAL PHOTOGRAPHERS

Kirk Tuck

Learn how to identify, market to, and satisfy your target markets—and make important financial decisions to maximize profits. *$34.95 list, 8.5x11, 128p, 110 color images, index, order no. 1890.*

CHRISTOPHER GREY'S

Studio Lighting Techniques for Photography

With these strategies—and some practice—you'll approach your sessions with confidence! *$34.95 list, 8.5x11, 128p, 320 color images, index, order no. 1892.*

Portrait Lighting for Digital Photographers

Stephen Dantzig

Dantzig shows you the hows and whys of portrait lighting and providing demonstrations to make learning easy. Advanced techniques allow you to enhance your work. *$34.95 list, 8.5x11, 128p, 230 color images, index, order no. 1894.*

500 Poses for Photographing Brides

Michelle Perkins

Filled with images by some of the world's best wedding photographers, this book can provide the inspiration you need to spice up your posing or refine your techniques. *$34.95 list, 8.5x11, 128p, 500 color images, index, order no. 1909.*

Photographic Lighting Equipment

A COMPREHENSIVE GUIDE FOR DIGITAL PHOTOGRAPHERS

Kirk Tuck

Learn to navigate through the sea of available lights, modifiers, and accessories and build the best arsenal for your specific needs. *$34.95 list, 8.5x11, 128p, 350 color images, 20 diagrams, index, order no. 1914.*

Corrective Lighting, Posing & Retouching

FOR DIGITAL PORTRAIT PHOTOGRAPHERS, 3RD ED.

Jeff Smith

Address your subject's perceived flaws in the camera room and in postproduction to boost client confidence and sales. *$34.95 list, 8.5x11, 128p, 180 color images, index, order no. 1916.*

Children's Portrait Photography Handbook, 2nd Ed.

Bill Hurter

Excel at the art of photographing children. Includes unique portrait concepts, strategies for eliciting expressions, gaining cooperation on the set, and more. *$34.95 list, 8.5x11, 128p, 150 color images, index, order no. 1917.*

CHRISTOPHER GREY'S

Advanced Lighting Techniques

Learn how to create twenty-five unique portrait lighting effects that other studios can't touch. Grey's popular, stylized effects are easy to replicate with this witty and highly informative guide. *$34.95 list, 8.5x11, 128p, 200 color images, 26 diagrams, index, order no. 1920.*

THE DIGITAL PHOTOGRAPHER'S GUIDE TO

Light Modifiers

SCULPTING WITH LIGHT™

Allison Earnest

Choose and use an array of light modifiers to enhance your studio and location images. *$34.95 list, 8.5x11, 128p, 190 color images, 30 diagrams, index, order no. 1921.*

CHRISTOPHER GREY'S

Lighting Techniques for Beauty and Glamour Photography

Create evocative, detailed shots that emphasize your subject's beauty. Grey presents twenty-six varied approaches to classic, elegant, and edgy lighting. *$34.95 list, 8.5x11, 128p, 170 color images, 30 diagrams, index, order no. 1924.*

WES KRONINGER'S

Lighting Design Techniques

FOR DIGITAL PHOTOGRAPHERS

Design portrait lighting setups that blur the lines between fashion, editorial, and traditional portrait styles. *$34.95 list, 8.5x11, 128p, 80 color images, 60 diagrams, index, order no. 1930.*